DRAWING BASICS

JACKLYN ST. AUBYN
New Mexico State University

HARCOURT BRACE COLLEGE PUBLISHERS

FORT WORTH PHILADELPHIA SAN DIEGO NEW YORK ORLANDO AUSTIN SAN ANTONIO
TORONTO MONTREAL LONDON SYDNEY TOKYO

Publisher	Earl McPeek
Acquisitions Editor	Barbara J.C. Rosenberg
Product Manager	Patricia Murphree
Developmental Editor	Helen Triller
Project Editor	Laura Hanna
Art Director	Vicki Whistler
Production Manager	Linda McMillan

ISBN: 0-15-503862-1

Library of Congress Catalog Card Number: 97-76771

Address for Orders
Harcourt Brace College Publishers
6277 Sea Harbor Drive
Orlando, FL 32887-6777
1-800-782-4479

Address for Editorial Correspondence
Harcourt Brace College Publishers
301 Commerce Street
Suite 3700
Fort Worth, TX 76102

Web Site Address
http://www.hbcollege.com

Printed in the United States of America

0 1 2 3 4 5 6 7 048 9 8 7 6 5 4 3

Harcourt Brace College Publishers

Preface

This book is the product of my experience in teaching drawing to beginning students. It contains a simple, straightforward structure for learning to draw that is based both on observation of the visual world and a growing awareness of visual language. Using perceptual responses as the springboard, students become aware of their own learning process with regard to drawing—a balance of attitude, confidence, state of mind, and skill acquisition. This awareness develops while they concentrate their attention on the specific tasks laid out in this book. In becoming aware of this process, they come to recognize the importance of such matters as developing self-confidence, learning patience, and turning loose of preconceived expectations.

In this book you will find very little discussion of techniques or advice on how to draw. Instead, the emphasis is on discovery within a carefully structured and directed context. The focus of this method is on building confidence and developing essential drawing skills.

Philosophy and Purpose

Emphasis on Student's Learning Process

I believe that the student's mental framework when learning to draw is as important, if not more important, than the information given in a textbook or in classroom interactions. It is not enough to provide the student with relevant information and an efficient procedure for learning skills. One must also encourage the development of productive attitudes. This book, through its tone and approach, focuses on the individual student and his or her learning process—that balance between mental attitudes and skill development. The text addresses the inner development of students as well as explanations of external elements. It is designed to serve as a companion to the drawing experience. Each chapter is organized in such a way as to assist students as they work on the assigned drawings and develop the related skills. Students are told *how* to approach a given task and *why*. Since elements of the learning process reappear throughout the book, each reappearance reinforces the student's understanding.

The Importance of Limiting What is Taught

One of the biggest obstacles to teaching beginning level drawing involves distilling the vast amount of information about drawing in a way that is meaningful and efficient enough to promote learning. Initially, every time I thought of an important element to include in developing students' drawing skills, several others would occur to me almost simultaneously. Yet I knew that bombarding students with this multitude of information would only confuse them. What I needed to present were only the most essential of considerations and a clear plan for development of the requisite skills involved.

Essential Drawing Skills

My first priority, then, became defining the essential skills necessary for learning to draw. The first skill on the list is learning to see—that is, learning to observe carefully. The book begins here, with helping students to understand how to observe the subject matter carefully.

The next essential skill is learning to concentrate and focus attention. Learning to concentrate doesn't come easily, especially to the younger student. For that reason, the pace of drawing in this book is slow, with ample time for consideration and for close looking. Learning to draw takes time. Creating this relaxed context encourages contemplation and enables students to take their time with drawings.

An added benefit of working slowly and concentrating is that of gaining access to the intuitive part of the mind. If students permit themselves to relax and let their sub-conscious work, then the perceptual abilities that they possess can come to the surface and aid them in their work of establishing connections between their eyes and hands.

Rounding out the list of essential skills that students must master in learning to draw are a few basic and altogether necessary formal considerations. These formal skills don't by any means make up a complete list of all the formal skills necessary in the education of a drawing student, but I believe they provide a sound foundation for future development. These skills include the following: developing hand/eye coordination, using line in a sensitive manner, constructing successful compositions, and using value and perspective to create form and spatial depth in drawings. Each of these skills is covered in depth; once a skill is added students use it repeatedly as their work progresses. Working in this way gives students extensive exposure to each skill, so that it becomes a permanent part of their learning.

Encouragement and Reinforcement

In addition to the need for simplification and clarity, beginning students need encouragement. I realized shortly after I began teaching that when I made an effort to point out students' accomplishments and to assure them of my confidence in their abilities, their learning progressed at a much faster pace. In contrast, if I opted for the expedient method of simply pointing out where improvement was needed, students just didn't experience the same leap of understanding. Consequently, the tone of this book and the philosophy behind its methods are those of reassurance and confidence regarding success. This is not an insincere attitude on my part, because I do believe this to be true. When students gain confidence in their abilities, their learning increases and this assures their continuing success. As a result, their drawing accomplishments often far exceed their original expectations.

The Instructor's Role in this Method

I know that teachers want to invest themselves personally in the classes they teach. This book provides a fundamental structure that is flexible enough for drawing instructors to use it as a foundation for the classroom and yet still be able to apply their own creativity, knowledge, and experience to the teaching process.

I believe that this will happen naturally as a result of the interaction that teachers must of necessity have with beginning students. The ongoing dialogue with students about what to look for in their drawings and how to "see" in new ways guarantees this on many levels. Obviously, for the critique sections, which are included in most chapters, the teacher's role in this regard is indispensable.

I have tried to make the explanations, instructions, and objectives in each chapter point towards a path for students to follow and give them the necessary equipment to successfully make their way. I believe that teachers can enter into this process and within this framework, devise their own methods for students to accomplish goals and increase understanding. I offer suggestions for subject matter and assignments that can be used as they are or as springboards for other solutions.

Emphasis on Still Life

As far as subject matter goes, I use still life as the basis for all but two chapters in the book. I have several reasons for doing so. The most obvious is of course that still life objects provide students with a subject matter that doesn't move and is always available. In addition, it is much easier to control lighting when using still life subject matter than, for example, when working from the landscape. Still life objects are inexpensive and readily available. They offer a wealth of possibilities with regard to form, texture, shape, and structure. Students can participate in the selection of objects, which aids them in developing their abilities to see subject matter in terms of shapes, lines, textures, and so forth. Instructors can easily set up a controlled situation where all students have the desired visual stimulus. Choices of subject matter can vary greatly and still meet the required standards with regard to assignment objectives.

The Illustration Program

The illustrations in this book are reproductions of student work. I decided to use student work instead of work done by accomplished artists for several reasons. First, I want students to see what others students have accomplished. The examples and standards are then reasonable in their minds. They have an attainable goal and some measure of what they can naturally expect from themselves. Consequently, even though they may doubt their own abilities in this regard, they can trust that these results are possible for them.

Second, student examples provide a visual explanation for what the text attempts to describe. Students can compare illustrations with verbal descriptions for a better understanding of the assigned tasks. Of course, once students finish the drawings, they can compare theirs with others in classroom critiques and gain even more insight.

Finally, by comparing student illustrations in the text, students can see that there are many possible solutions to a drawing problem. It is not necessary or desirable for everyone to resolve the exercises in the same way. There is much room for individuality and personal expression through different points of view and uses of the medium and formal elements.

Although I have selected students' work to illustrate this book, students also benefit greatly from seeing work done by accomplished artists. For this reason, showing slides or taking students to area exhibitions is a valuable addition to the classroom structure.

Elements of the Organization

This book is applicable to foundation and beginning drawing classes. Students draw from observation, with an emphasis on process and discovery. The organization of this book enables students to learn skills in a progressive order. Skills learned first support and clarify skills to be learned later. I have tried to structure a logical and efficient progression from the first exercises on learning to look to the final ones about using value and perspective to create form. For that reason, I recommend using the chapters in the order in which they are presented.

Each chapter's organization reinforces the student's interaction with the basic drawing exercises that are the heart of the book. At the beginning, each chapter introduces the subject with some general descriptions of how students should approach the drawings and why. Next, two or three drawing exercises are given, with subject

matter, objectives, and directions for the assignments. Following this, under the heading "Refining Your Skills," detailed explanations discuss the given objectives, describe the relevant formal elements, and suggest ways to approach the assigned drawing tasks. While they are working on the exercise drawings, students should read and reread this section of the chapter. Most chapters also include a sketchbook assignment that directs students in their daily practice in drawing. Finally, each chapter contains a section on critiquing drawings that critically directs discussion of the drawings. Because critiquing requires that students reassess the problems they're solving and the aims of the chapter, these sections also serve as a summary of the chapter's content.

Acknowledgments

My first thoughts of appreciation extend to the many beginning drawing students I've had over the past twelve years. Without their enthusiasm, commitment, and hard work, this book would not have been possible. It is uncanny how naturally and easily the philosophy, structure, and elements of *Drawing Basics* emerged from my experience with these students. Specifically, I thank the many students who contributed drawings for reproduction in this book. It was difficult to decide which drawings to include because I was offered so many successful ones from which to choose. My choices were therefore somewhat arbitrary. However, I've tried to include those drawings that most clearly illustrate the specific objectives and instructions given with assignments. All student works were photographed for the book by Gerald Moore.

I am indebted greatly to my family who have supported me throughout this project. Their confidence in me and their willingness to discuss ideas and give me feedback provided me with an endless source of support and guidance. Many thoughts of appreciation go to my husband, Joshua Rose, for his constant faith in my abilities and his much needed encouragement. Without him, I couldn't have done it. I also wish to voice my appreciation to my sons, Keith St. Aubyn and Cris St. Aubyn. They have contributed immensely through their emotional and intellectual support of my efforts. Keith went far beyond the call of duty when he enrolled in my drawing class so that he could critique the book more sensitively. I thank also Melisa Pippen and Dawn St. Aubyn for their never ending confidence in me, especially at moments when my spirits were low and my energy depleted. I am most fortunate and grateful to all of them.

My ability to revise and expand the manuscript was made easier by contributions from several colleagues. I thank Suzy Davidoff, Louis Ocepek, Mary Wolf, Mark Perlman, Kurt Kemp, Dale Newkirk, John Gustinus, and Lea Rano for their assistance. I also thank my graduate assistants who have put their sincerest efforts into teaching drawing and who have given me invaluable responses to both the book and the classes.

Several other instructors also reviewed materials from the manuscript and offered critical responses and helpful suggestions. I appreciate the time and effort expended by the following individuals in advising me on ways to improve the book: Ed Shay, Southern Illinois University; Al Souza, University of Houston; William Zwingelberg, Catonsville Community College.

Finally, I would like to thank Barbara J. C. Rosenberg, senior acquisitions editor, for her faith in this book and Helen Triller, developmental editor, for her unbelievably empathetic and creative assistance in revising the manuscript.

Contents

DRAWING BASICS

To see a World in a Grain of Sand
And a Heaven in a Wild Flower
Hold Infinity in the palm of your hand
And Eternity in an hour

William Blake

Introduction

Why This Book?

When I was a child, one of the things I wanted most was to be able to draw. I spent hours copying pictures out of magazines, comic books, anything I saw that caught my eye. Eventually my diligence paid off and I learned to draw. Since that time drawing has given me a great deal of personal gratification.

I think that my desire to draw is shared by many people; even as a child I could see that others admired my drawing and wanted the ability to do the same. While I recognized that persistence and hard work had brought me to this level of accomplishment, I was confused as to why my classmates thought that the same accomplishments were not possible for them. I thought that drawing was as natural as thinking and seeing. Nevertheless it was obvious that others did not share my point of view; they considered the skill of drawing to be a gift; you either had it or you didn't.

When I became an art student in college, I was surprised to find that attitudes had not changed. Despite their exposure to drawing classes, most students surrounded drawing with mystery. I still believed that there were more obvious and understandable reasons behind knowing how to draw. After all, I had taught myself a great deal about drawing, and I knew I had done this through persistent hard work.

Later, when I began teaching drawing classes to college students, I had the opportunity to explore my thoughts on this matter further. Because it was necessary for me to explain clearly to students how they should go about learning, I tried to "unwind" my thoughts and return to the sources of my understanding. Gradually, in the course of several years of teaching, I was able to pin down in detail how I learned to draw and a method for others to do the same. This book is a product of that experience and of the years of teaching behind it.

As a teacher I am often approached by people who tell me how much they want to learn to draw and how incapable they feel about doing so. My answer to them is that drawing is a skill, and with the desire to learn and motivation to practice, it is possible for anyone to learn. This conviction underlies my teaching methods and provides the philosophical basis for this book.

In the 12 years that I have taught drawing, my students have proven me to be right. It is one of my greatest satisfactions to hear students tell me how surprised, excited, and empowered they feel at discovering that they have the ability to draw.

As you look through this book and work on the exercises, it will no doubt lift your spirits to look at the examples and see what other students, similar to you, have accomplished using the method presented here.

One of the principles stressed in this book is the importance of generating a structure for learning that encourages confidence and the feeling of capability. With this goal in mind, I have made every attempt to create a text that provides clear instructions and explanations. This way there is less uncertainty over what instructions mean or how to go about following them. I also explain *why* I ask you to approach drawings in a specific way. This allows you to put what you are learning into a context based on understanding of what you are trying to accomplish. Similarly, I go into detail about what constitutes success or failure of the given tasks. This counteracts the tendency you might have to assess drawings as good or bad based on arbitrary evaluations by providing you with a reasonable system for measuring quality.

I make it clear exactly where you need to begin in learning to draw, and I simplify the number and the extent of the skills that you learn at this beginning stage of drawing. This approach to drawing assures your success at the outset, thus establishing a firm basis for future learning of more complicated skills.

There is still some mystery left in drawing, for making images can be making magic. That is why so many have such a strong desire to learn to draw. However, the actual process of learning to draw, the skills of making images—these are what I want to clarify.

Apart from my motive of making the skill of drawing understandable and accessible to those desiring to learn, I have another reason for writing this book. I believe that learning to draw by using the methods I outline here increases your ability to think creatively. What you learn here you can apply to many other areas of your life. I have no doubt that you will see that by improving your powers of observation and by sharpening your intuitive and perceptive skills, you are able to approach many tasks other than drawing in a more focused and aware manner, making it possible to break away from old habits and to see new possibilities.

How to Use This Book

To get the most from your efforts as you work on the exercises in this book, remember four important guidelines:

Be Positive and Not Overly Self-Critical

Thinking positively is extremely important to your success in drawing. Your mental attitude sets the stage for the drawing process. Thoughts or statements criticizing what you are doing only interfere with your learning and with your ability to do the drawings well. It may take some effort on your part to break the habit of self-criticism, but replacing it with an acceptance of what you are doing and an openness to the possibilities will greatly speed up your progress and your ability to learn. Consequently, although you may have preconceived ideas of what a good drawing looks like, and you may tend to impose these expectations on your own drawing, it is important to break loose from these judgments and be open to unexpected results. You may discover that your ideas of what defines "good" drawing will have changed immensely by the time you finish the work in this book.

Follow All of the Directions Carefully

The specifics of each assignment, as well as the order in which you do things, are meant to introduce you to skills and concepts as you need them. The instructions are there to enhance your discovery process. Similarly, each element evolves from what comes before and influences what follows. For these reasons, it works best to follow the directions carefully and do the exercises in the given order.

Even though the directions are straightforward, you may find that following them requires a surprising effort on your part. This is because you may have developed habits in drawing or in other activities that interfere with your following the directions. You may have a mindset that prevents you from adopting the appropriate mental attitude. Try to prepare yourself for this resistance and make the commitment to change habits and approach the work with a fresh mind, open to new possibilities.

The directions in this book provide you with a clear and specific structure to your learning process in drawing. However, within these boundaries you will discover there is considerable freedom to explore your personal preferences and artistic sensibilities. The success of this method for learning to draw is due to this clarity of structure, combined with an encouragement of creative responses.

Spend a Sufficient Amount of Time on Each Drawing

In most cases, you will work slowly as you draw. It is important that you spend the necessary amount of time on each drawing. This may mean that you have to slow down your drawing pace and not work as fast as your natural inclinations might tell you to work. Most of us are not in the habit of doing things slowly. Life is too hectic and we have too much to do. However, in this case, working slowly is the key to success for two reasons. First, it allows you to see more, and as you will learn, seeing is the key to drawing (more about that later). Second, working slowly sets up a mental environment that is conducive to concentration, relaxation, and intuitive learning, all of which are important factors in this drawing process.

If You Are Not Sure of Something, Ask Your Instructor

Even though this book states the objectives of each exercise and how to approach them successfully, you may have questions. Do not hesitate to ask your instructor. Learning a skill is very much about getting input from others. Your instructor is there to assist you and even though he or she will be giving you time to work independently without interference, at the moment you feel you need clarification, it is important for you to ask.

Similarly, do not hesitate to look around at what your classmates are doing and talk to them about the drawings. Drawing is visual and seeing what someone else does provides you with important information. You can find answers to problems that have you puzzled by seeing another person's solution. Admiring one of your classmates' drawings can give you insight into how to proceed with your own. There should be a dialogue going on in the drawing classroom—one that encourages a workshop attitude with people learning from each other. In addition, you can refer to the illustrations in this book; they are examples of work done by other students.

I always try to program students for success, setting up something I know they can handle, increasing the complexity and problems as their eyes and artistic abilities grow.

Audrey Flack
Art & Soul, Notes on Creating

Chapter 1: Practicalities

Chapter Organization

Chapter organization in this book reinforces your drawing process. The main focus of each chapter is the activity of drawing and the information given supplements this activity. Following are descriptions of the chapter parts with explanations of their purpose.

Basic Topic

Each chapter begins with a basic topic and a description of its main components. It is here that you learn what objectives to focus on and how to go about doing this. In each case, you begin with a skill that you have and work on acquiring the designated new ones. For example, Chapter 2 deals with observation (a skill that each of us has) and helps you focus and strengthen that skill through directed activities contained in the exercises and sketchbook assignments. Chapter 3 then begins with the newly improved skill of looking closely and continues from there. Each step of the learning process stems from previous learning and at no time are you in a situation where you don't know how to begin. The basic topic section of each chapter sets the stage for work you do with the exercises and lets you know what to expect.

Basic Drawing Exercises

The basic drawing exercises for each chapter follow the topic description. Instructions in these exercises are thorough and self-explanatory. They describe materials, subject matter, and objectives in detail. This information tells you what you are trying to accomplish and how to go about doing it. The basic exercises are the core of each chapter because they define the drawing activities that serve as the basis for learning what is needed at this time. At all times, the primary focus is on the drawing process and what you are learning as you engage in the prescribed activities. Everything revolves around your involvement in this process.

Helpful Elaborations

Following the exercises in sections entitled "Refining Your Skills," you will find further elaborations of the given problems for any one chapter, with helpful information to assist you in successfully completing the drawings. This part of the

chapter coincides with your drawing activity. It provides more detailed and specific information related to both formal and technical elements. It should be helpful for you to read and reread this material as necessary while you are working.

Sketchbook Exercises

After the section on refining your skills in each chapter come the sketchbook exercises, which you do on your own outside of class. Working in your sketchbook should be an ongoing process. With each chapter will come a new sketchbook assignment that reinforces the other drawing exercises in the chapter. Sketchbook exercises provide a method to practice and master the skills that you are learning at this step of the process. It is a good idea to read over these instructions and begin the sketchbook assignment as soon as you feel somewhat comfortable with the corresponding drawing you are working on in class.

Regular practice in the sketchbook enables you to develop spontaneous responses from eye to hand. These sketches are quick studies and should take you only a short time to complete. Even though your sketches will take less time than your in-class drawings, the same principles apply to each, especially the principle of looking closely. Working in your sketchbook allows you to practice seeing quickly and clearly and to make accurate judgments based on what you see. The direct and intuitive manner of sketchbook drawing serves as a useful complement to in-class drawing. Think of these sketches as warm-up exercises that keep you limber and alert for the new skills you are acquiring.

Directions for sketchbook exercises include suggestions on subject matter that is compatible with that for in-class drawings. When choosing what to draw, look for interesting shapes, lines, and textures to guide your decisions.

Date each drawing to keep a record of your sketches.

Drawing Critiques

At the conclusion of each chapter is a critique section with discussion and questions that review the basic drawing goals of the chapter. The text here is an aid to looking at drawings and determining if they reflect a successful accomplishment of these goals.

Reading over this part of the chapter helps you make constructive comments during class critiques on how successful drawings were in meeting the established goals. This part of the drawing process is helpful in determining your progress and in assisting you to make mental notes of what you might improve in the next drawings.

Questions listed at the end of the critique section give you further direction. If you answer these questions thoughtfully, you will have relevant information to use in critique discussions. More information about the critique process appears later in this chapter.

Basic Materials

To do the work for the first six chapters of this book, you will need a minimal amount of art materials. In the last five chapters, the number of materials you will need becomes more extensive. However, all required materials are inexpensive and easily obtained. They will be available in any art supply store, or if necessary, even in general merchandise stores.

BASIC MATERIALS FOR BEGINNING CHAPTERS

masonite drawing board, at least 24" x 36" in size

36" ruler

Two metal clips for holding paper onto board

Inexpensive white drawing paper, at least 24" x 36" in size

Waterproof black marking pens (broad tip, medium line, fine line, ultra fine line)

8 1/2" x 11" sketchbook, spiral or bound

I have tried to be general when it comes to specifications of what you will need so that you can make use of what is available. However, it is important that you comply with these general requirements, because in large part the skills you are learning will be dependent on the use of these particular materials. Later, as you develop further in your abilities, this will not be the case and you will probably have your own preferences with regard to materials.

Creating the Best Possible Environment for Drawing

Your state of mind when you draw plays a part in your ability to apply yourself to the work. In this method of drawing, you rely on your intuitive and perceptual responses while working. Utilizing this part of your mind requires a relaxed, quiet mental state. Because of this, you need to set up an environment that is conducive to feeling comfortable and relaxed. You need to be able to concentrate without distraction. Therefore, there should be no unnecessary talking or disruptive noises. Music is helpful, but should be of a meditative nature, like classical music. Also, the way you physically situate yourself affects your ability to draw. For this reason, it is important to sit or stand in a position that enables you to see the subject matter clearly and reach all parts of the drawing as you work.

Setting up the Work Area

There are just a few considerations that will be important when it comes to a work space for drawing. You need enough room to set up your materials and, if necessary, your subject matter. If you are working from a still life you must have a close, unobstructed view of the subject matter. The room needs sufficient light for close observance of detail and adequate ventilation for physical comfort and safety.

You will have your own drawing board that you hold at an elevated angle. The most efficient method for this would be sitting at a drawing bench or standing at an easel where you can be working and support the board at the same time. Drawing in this way gives you the best angle of vision of the drawing board. Working flat on a table surface is not desirable.

BASIC MATERIALS FOR FINAL CHAPTERS

several sticks of compressed charcoal

charcoal pencils (HB, 2B and 6B)

kneaded eraser

Pink Pearl eraser

Pink Pearl eraser pencil

several sizes of blending stomps

1" or 1 1/2" flat brush for blending

pencil sharpener

soft cotton rag

100 percent rag drawing paper, cold press, at least 24" x 36" in size (Arches, BFK, Lana, etc.).

Classroom Critiques

Definition of a Critique

The last section in each chapter of this book, except for Chapters 2 and 11, is on drawing critiques. A critique is a situation in which students and instructor discuss finished drawings. Although the instructor guides discussion and ensures that the critique covers relevant points, it is also your responsibility as a student to participate fully in the discussion.

In a critique students usually put their drawings on the wall and discuss each in turn. Displaying the drawings in this way gives you an overview of your accomplishments and lets you make comparisons.

Students and instructor sit in front of the drawings and close to the work so that the surfaces and details of drawings are clearly visible and it is possible to hear what everyone has to say. The critique area should be free of distractions and outside noises. It is important that participants feel comfortable. Discussion occurs more easily when this is the case.

Importance of the Critique

Discussing work in a critique situation gives you the opportunity to put into words thoughts and realizations that you may not know you have. Talking about drawings provides other points of view on the process of learning to draw. Just as you learn by looking and drawing, you also learn by speaking about what you have done.

Your participation in critiques is important for three reasons: (1) Finding ways to verbalize what you think of a drawing reinforces what you have learned in the process of doing it; (2) what you have to say to your classmates comes from a shared experience and is helpful to them for this reason; (3) talking about work helps you to understand the vocabulary of art that is important to your learning process.

What you gain from getting feedback from others on your work is also important. It gives you the benefit of incorporating what your peers have learned into your own experience. The critique is therefore a collaborative process.

Difficulties of the Critique

Despite the benefits to be derived from in-class critiquing, most students approach critiques with some degree of apprehension. This is partly due to lack of experience and partly due to the personal nature of drawing. To help you feel more comfortable with it, read the sections that follow on the process of critiquing; they establish some ground rules that you should adhere to when participating in classroom critiquing sessions. These sections will give you some guidelines for setting an appropriate tone for this part of the learning experience and for approaching discussion of the drawings.

The Importance of a Positive and Constructive Critical Attitude

Above all other considerations, the tone of critiques should be positive. Your instructor should be careful to point out what is being done well in each assignment before discussing problem areas. These comments should be sincere and insightful. Students should also take care to preface any suggestions for improvement in work with acknowledgment of and appreciation for the drawing's successes. Negative comments and one-sided criticisms are a barrier to the learning process. All of us learn more efficiently within a supportive framework. If someone has sincerely worked at the assignment, there will be something positive to comment on in his or her drawing.

Feedback on improving the drawing is a necessary part of critiques. However, comments on work need to be constructive, not destructive. Studio work is a process in which learning takes place over a period of time. This process accelerates with the help of "objective" eyes. Sometimes others can see what you need to do in your drawings more easily than you can because they have a mental distance from the drawing. It is important for everyone to comment on what can be done to improve the drawings. However, it is equally important to take care as to how you phrase the comments.

One of the most important considerations to keep in mind is that in no case is the work the same as the person who created it. In other words, there is a distinct separation between the drawing and the student. This may seem obvious, but often we tend to think of the work as an integral part of ourselves. When someone comments on what we do, we take it as a comment on our value as a person. This is not valid and it is important that when we discuss others' drawings we not direct comments to what the person has done, but instead to what is in the drawing. This point is especially important because in the beginning you or your peers may tend to be excessively self-critical and far too subjective about the drawings you are creating. Separating the work from the person helps to put things in the appropriate perspective.

Keep Assignment Objectives in Mind

As a way of preparing yourselves for critiquing sessions, go over the objectives of the assignment listed in the book. Each chapter discusses the basic exercises in

detail and points out important concerns in the section headed "Critique on Drawings". Rereading this information before critiques focuses your attention and should make the critique more productive.

The questions in these sections prompt you in discussing the work. As you look at drawings, ask yourself the questions and turn your answer into a statement about the work. Don't be afraid of saying something obvious. What may seem obvious to you, others may not have noticed.

In discussing a drawing, points may come up that the book does not cover. Do not hesitate to bring up responses or observations you may have in this regard. Critiques can be open-ended, and such discussions may lead the way into new territory.

Work to Develop an Artist's Vocabulary

It is true there is a vocabulary in art that probably contains words that are unfamiliar to you that you need to learn. This book uses boldface type in the text to point out definitions of important terms. Rereading these definitions will help you to remember them when discussing drawings.

One of the purposes of critiques is to help you further develop your artistic vocabulary. During critiques, as unfamiliar words and complex comments arise, your instructor will define words and clarify concepts. Do not hesitate to ask for such clarification if new terminology or artistic concepts arise during a critique session. Most important, do not be hesitant to discuss drawings because you do not think you know the correct word to describe the images. You are in the process of learning the vocabulary, and participating in the discussion is the first step in this direction.

Look Closely and Speak Thoughtfully

Most of the time we think we look closely and know what we see, or at least what we like. However, to speak in a perceptive and helpful way about another's work, we have to look very closely and explain very carefully what we find. This process of translating visual responses into verbal ones is a meaningful part of learning.

To accomplish these translations effectively we have to look at images from a different perspective. This perspective is one of attention and focus. Looking closely at the drawing, making note of key characteristics, and then putting these responses into verbal terms is a complicated process. You cannot make assumptions or rely on empty descriptions. Be detailed in your comments and avoid simple statements such as "I like this" or "I don't like that." Replace such statements with descriptive, thoughtful observations of how elements function in the drawings.

Learn from Others

Critiques are a helpful way to establish a dialogue with other students. Much of what you learn, you learn from each other. In many cases, your peers understand what you are trying to accomplish and the problems you are trying to solve. After all, you are all doing it together. This is the benefit of critique sessions. In them, when discussion opens up, your work progresses more rapidly and you are able to understand what you are doing more readily.

Simone Weil says, "Absolute attention is prayer," and the more I have thought about this over the years, the truer it is for me. I have used the sentence often in talking about poetry to students, to suggest that if one looks long enough at almost anything, looks with absolute attention at a flower, a stone, the bark of a tree, grass, snow, a cloud, something like revelation takes place.

May Sarton
Journal of a Solitude

Chapter 2: Looking

The single most important thing you must do to learn to draw is learn to look. This may seem obvious, but most of us take looking for granted. We assume that we see what is there to be seen. In most instances of everyday life, this is sufficient, even extremely efficient. When we look at our complex environment and focus on what is necessary, we omit many things from our attention. When crossing the street, we have to focus our attention on the oncoming traffic and the traffic signal, not on the color of the Spanish Broom filling the flower beds next to us. Otherwise, we would not survive very long.

In this first step of learning to draw, you must reverse the process. You need to become aware of every detail. The most important thing for you to do is to look closely as you draw. You will look for every mark that you make. You will also work very slowly, as you look carefully. Working slowly allows you to concentrate on what you see. As you sharpen your ability to see, you also develop your ability to concentrate. If you find that you are being frustrated or impatient, get up, walk around, and then come back to the drawing. It often takes practice to develop the ability to look, work slowly, and concentrate.

Drawing the Contours of Shapes

For your first drawing, you are going to do a contour drawing of your subject matter.

Contour is the line that defines the shape of a form. If you were to put your hand on the paper and trace around the outside of it, this would be a contour drawing. For our purposes now, do not draw values. **Value** is the gradation of tone from light to dark, from white through gray to black. Focus only on the shapes that you see. In Figure 1, the student drew only the contour outlines of shapes. There are no values indicated in this drawing.

Look closely as you draw. Do not think about the outcome and whether your drawing will look like the subject matter. Pay attention to looking and making marks based on what you see. Relax and concentrate.

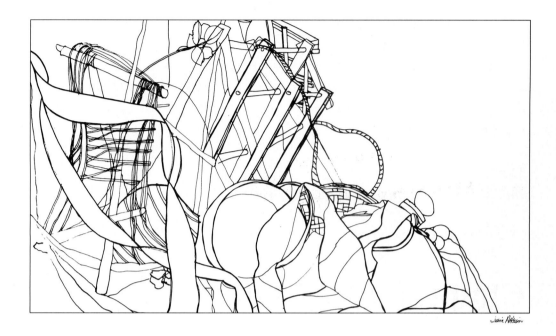

Fig. 1 *Contour drawing showing outlines of shapes*

Focusing on the Visual Relationships of Shapes

You will begin with a complicated subject matter with many shapes. You are to draw all of the shapes that you can see. Because of the complexity, you will need to keep focusing on what you are seeing. It will be easier if you draw shapes that are next to each other spatially. In other words, begin with a shape anywhere, then draw the one next to it and then the one next to that and so forth. Let the drawing develop organically. This is important because part of learning to draw is seeing visual relationships. To do this easily, you must look at shapes that are in close proximity to each other. Doing this also allows you to attend to the looking and not to become distracted by proportions or by making the drawing "look right."

Drawing the Rectangle of the Picture Plane

The **picture plane** is the two-dimensional surface on which you work. The rectangle that you draw in the beginning of each drawing represents the picture plane. Every mark that you make within this rectangle is part of your drawing.

To make it easier for you to be aware of this picture plane and to include every part of it in your drawing, you should draw the edges of this rectangle. Use your ruler to do this; this is the only time you will use a ruler when drawing. Every drawing you make using this book will have these drawn edges of the picture plane.

✦ BASIC DRAWING EXERCISE 1

Materials: Black marking pens of various sizes
Inexpensive white drawing paper at least 24" x 36"

Subject Matter: Complex still life with many organic patterns and shapes (see Figure 1).

Objectives: Your goal in this drawing is to look closely at the shapes you see in the subject matter. Focus on visual relationships by looking at individual shapes that are next to each other spatially. Work slowly.

Directions: Draw the rectangle of the picture plane. Choose a part of the still life—a part that you like. You need not choose a large section. Blow up the image; draw shapes larger than you see them. The drawing will be larger in scale than the actual forms.

 Scale is the relationship of size between one form and another, in this case between the shape you draw and the shape you see. In other words, you will be drawing the shapes "larger than life-size."

 Do a contour drawing of the shapes that you see. Include as many shapes as you can. Notice that there may be shapes within shapes. The complexity of the still life that your instructor has set up for this exercise encourages you to look more closely. Do not assume that you know what the shapes look like. This complexity also makes looking easier because it also allows you to move easily from shape to shape as you look at visual relationships.

 Look closely as you draw; look for every mark that you make. **Line** is the path of a moving point, or a mark made by a tool or instrument as it is drawn across a surface. Keep your lines flowing and rhythmic by not picking up the pen any more than is necessary.

 Do not concern yourself with accuracy of representation at this point. You should not be thinking about this. Instead, focus your attention on looking closely and seeing visual relationships.

Suggested time allowed is two to three hours.

✛ REFINING YOUR SKILLS

Line Quality and Its Importance

The line quality in your drawings is very important. As you become more familiar with drawing, your appreciation for lines will increase. You will notice if lines are awkward and stiff or if they are graceful and rhythmic. You will discriminate between lines that describe shapes sensitively and accurately and those that fail to do this.

Lines reveal how much you are concentrating and how closely you are looking. They tell us if you are self-conscious or relaxed about your drawing. How you approach your drawing, both mentally and physically, shows in the appearance of your lines.

You can control the quality of your lines through the drawing methods you use. For the most rhythmic, flowing lines, do not pick up your pens any more than necessary while you are drawing. Avoid short, sketchy lines. Let your pen run smoothly in a continuous line whenever possible. This allows you to describe shapes intuitively, based on what you are seeing. You can capture the entire shape with a continuous line that is natural and rhythmic.

You can improve the quality of your lines by relaxing while you are drawing. Try not to think about the outcome or product; instead, focus your attention on looking and drawing what you are seeing. If you are not thinking about the way lines look, chances are they will be much freer.

Benefits of Not Erasing

You are using marking pens that do not erase for a reason. The fact that you cannot erase what you think of as an error encourages you to look even closer before you put lines down on the paper. Students tend to rely on erasing as a way of compensating for lack of attention or close looking. When you can't erase, you will work more slowly and avoid hasty responses to what you are seeing.

Also, you will probably find that even though the finished drawing includes some lines you consider to be errors, the quality of the drawing does not suffer. There is more flexibility in drawing than you might have thought. Knowing this should encourage you to loosen up and be more limber than you would be otherwise.

❖ SKETCHBOOK ASSIGNMENT

Materials: Marking pens, sketchbook

Directions: Do a drawing every day. Date each drawing. Do contour drawings in your sketchbook of complicated scenes. These may be interiors of rooms, or landscapes, or just the corner of a tabletop. Figure 2 and Figure 3 are good examples of such subject matter. The important consideration is that there be many shapes in the subject matter. Draw only the shapes, not the values you see. These drawings are quick studies, but you should still look closely.

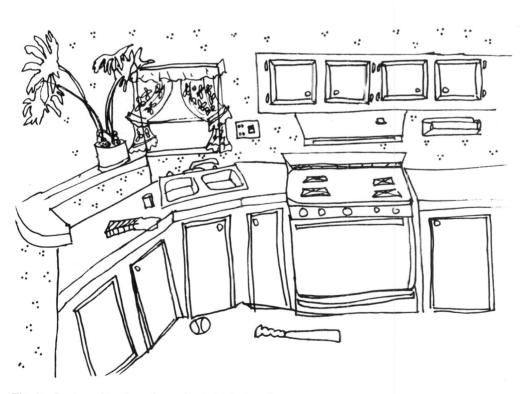

Fig. 2 *Contour drawing of complicated interior of room*

Fig. 3 *Contour drawing of complicated subject matter*

❖ DRAWING CRITIQUE

What are the Objectives?

The main purpose of this first drawing was for you to look closely and to draw what you saw. By doing this drawing and the sketchbook drawings you should have established a close relationship between what your eyes see and what your hand draws. It does not matter if your drawing looks like the subject matter. Your main focus was looking closely and relaxing.

When discussing this drawing, look at the quality of lines and the definition of shapes. Does it look as if the person was looking closely, and is there a relationship between the lines drawn and the subject seen?

How Do You Determine if the Objectives Have Been Accomplished?

The first thing to notice in the drawing is the shapes. There should be a looseness and life to the shapes; they should not be rigid and stiff. There should be a variety of shapes, not a lot of obvious repetition. In Figure 4, the shapes have an irregular quality to them. This irregularity indicates the person was concentrating on looking as he drew. The shapes, even though they are obviously similar, have a variety to them that also reveals

Fig. 4 *Irregular quality of various shapes indicates close
observation by the artist*

close observation. Sometimes if there is an obvious repetition to shapes, it
means that the person was not looking closely enough

It is the tendency of everyone, experienced or not, to draw what they
think they see and not what they actually do see. This is a habit to break
at the beginning. You need to constantly refresh your vision by looking
intently at the subject.

Another consideration in looking at this first drawing is the line qual-
ity. It is important to have lines that are natural and flowing. This will add
visual interest and life to the drawing. Notice how lines in Figure 1 appear
to be graceful, continuous, and natural as they describe the shapes in this
drawing.

The attitude that prompts this sort of line is a relaxed one. It is impor-
tant to relax with the drawing. This state of mind will lead to better and

Fig. 5 *Contour drawing with flowing lines*

more efficient concentration. So, how do you know if lines are flowing? Flowing lines will be for the most part unbroken. There will be a looseness and spontaneity to them. They will be, just as the word flowing indicates, of a liquid nature. Above all, they will not appear stiff or uncertain. The lines in Figure 5 have this flowing, loose quality. If you cannot detect these qualities in lines now, do not worry; as time passes you will become familiar with them.

Questions to Ask Yourself When Discussing Drawings for Exercise 1

l. Does the drawing indicate that the person was looking closely? What about the drawing tells you this?
2. Does the drawing have flowing lines? How do you know this?

What is art but a mold in which to imprison for a moment the shining elusive element which is life itself . . . life hurrying past us and running away, too strong to stop, too sweet to lose.

Willa Cather

Chapter 3: Developing Patience

Much of what you need to develop at this stage of learning the process of drawing is patience. As you sharpen your ability to look more closely and further develop the hand-eye coordination skills that come from doing so, you may find that you experience frustration, either because the process is going too slowly or because you feel you can't control what you are doing. It is important that you confront this impatience or frustration and continue to work by looking closely and drawing slowly. This may be the most difficult task you will face. In fact, learning to draw is easy once you have mastered this.

Looking Carefully and Drawing Slowly

The next drawing exercises will help you acquire this patience by drawing objects with complicated structures. There is no way to draw these objects hastily and still observe them carefully. The nature of the subject matter forces you to become involved with the complexity and to look intensely. You may have to focus and refocus to continue these drawings.

Looking for Variety in Shapes

Often, what may at first glance appear to be identical shapes are in reality many shapes of similar but varying appearance. By careful observation, you can distinguish this variety. Look carefully for each shape that you draw. The student drawing in Figure 6 displays a complexity and variety of shapes that show how carefully the artist observed the different shapes within the flower.

Above all, do not draw what you think you see. Do not repeat a pattern of shapes that you assume is there. You may find that you have a tendency to do this. We are all in the habit of making assumptions about what we see—of generalizing shapes, for example. However, in learning to draw you must break this habit and allow yourself to concentrate on observing the shapes carefully. You should find that as the drawing progresses, so does your ability to see an object in all its complexity.

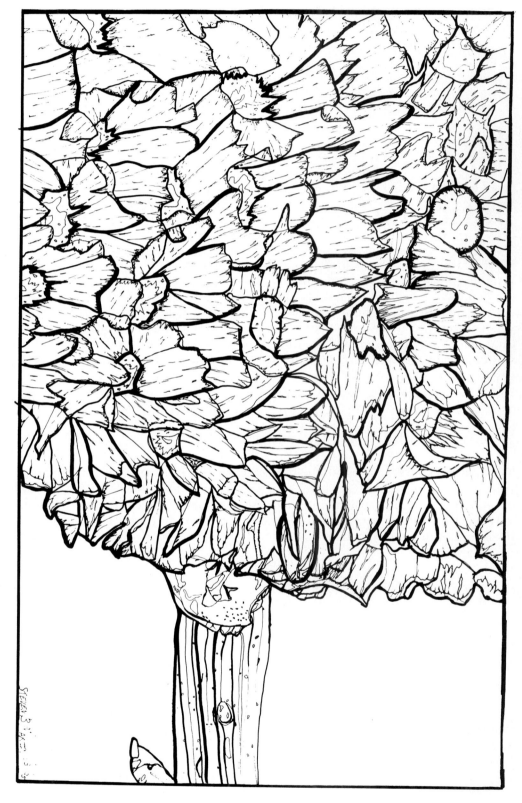

Fig. 6 *Line drawing showing complexity and variety of flower shapes*

Drawing Shapes in Relation to Each Other

Again, because you are drawing relationships of shapes to each other, you should continue to draw shapes that are next to each other spatially. Because the objects for this chapter's exercise are so complex, it should be helpful to begin at the outer contour and progress inward as you are drawing. It is important not to draw the entire outer contour of the object at first. Instead, draw only small parts of it as you work on the shapes inside the object. In other words, begin by drawing some shapes at the outside edge of the object and progress slowly from one shape to another, moving inward toward the center of the object. Repeat this process until you have a large portion of the inner shapes drawn. Finishing up the outer contour will then be fairly simple. The reason for this progression is that if you draw the entire outer shape of the object immediately, you will probably misjudge the size and shape and will be left in a position of having to compensate for this. If you only draw parts at a time, then you will build up the size and shape slowly, in relation to other parts of the object. Chances are that you will be more accurate.

You will be working from a single object that you can put near your drawing board. To make it easier for you to focus on the shapes and see them clearly in relation to each other, the object should remain in a stationary position so that these relationships remain constant. For this reason, don't pick up the object or move it as you are drawing. Use a magnifying glass to get a closer look at the shapes and lines of the object.

You might find that you have difficulty keeping track of what part of the object you are looking at when your eyes move from object to drawing paper. Here is where patience comes in, as you work to re-focus and find your position constantly. Think of this part as a drawing workout. You are training your visual memory and improving your ability to concentrate as you do this.

✦ BASIC DRAWING EXERCISE 2

Materials: Black marking pens of various sizes

Inexpensive white drawing paper at least 24" x 36"

Subject Matter: Your instructor may provide this subject matter. If you provide your own, choose a natural object with a complex, repetitive structure composed of a large number of shapes. Dried sunflowers are a good example of such subject matter.

Objectives: Your goal in this drawing is to look closely at the shapes you see in the object and draw each one individually. As a result of doing this, you will develop your ability to focus and concentrate on what you are seeing. You also have to think about composition when you place the image within the picture plane.

Directions: Begin by drawing the picture plane with a medium-sized marking pen. Think about composition. The composition of your

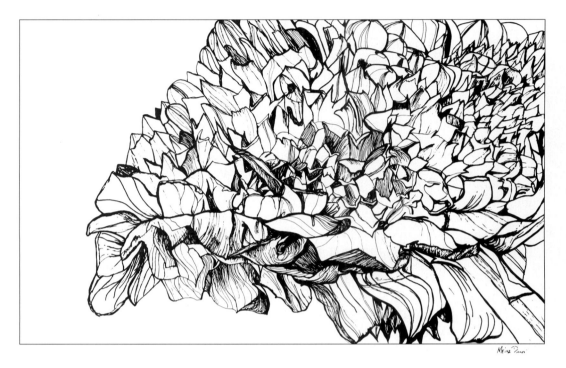

Fig. 7 *Contour drawing demonstrating effective placement of flower image within the picture plane*

drawing is the arrangement of shapes within the picture plane. Because you are working with a single object you need to consider how you will position it to assure that your composition is satisfactory. In this drawing, the image should touch or nearly touch at least three edges of the rectangle. The drawing in Figure 7 is a good example of placement of the image within the picture plane.

Draw the inner and outer contours of the object. The inner contours are the many shapes that compose the object as a whole. Do not use values, only contour lines. Don't blacken in shapes. Vary the width of your lines by using the different sizes of pens.

Look very closely as you are drawing each individual shape. The marks should be in response to what you see. As you can see in Figure 7, there are many different shapes that compose the flower in this drawing. You don't have to draw the entire object, but you should work large—blow up the image in scale.

Work slowly and look closely. If you find that you are getting frustrated or impatient with the drawing, get up and walk around. Take

short breaks when necessary. As your ability to concentrate increases, your level of impatience will decrease.

Suggested time allowed is eight to ten hours.

✦ BASIC DRAWING EXERCISE 3

Materials: Black marking pens of various sizes
 Inexpensive white drawing paper at least 24" x 36"

Subject Matter: Fruits or vegetables with complex structures.

Objectives: Your goal in this drawing is to look closely at the complex structure of the subject matter and draw what you see, not what you think you see. You also have to arrange the objects in such a way as to create a satisfactory composition in your drawing.

Directions: Draw the picture plane with a medium-sized marking pen. The finished drawing should touch or nearly touch all four edges of the picture plane.

Choose one or two fruits or vegetables with complex inner or outer structures for this drawing. Find ones that appeal to you visually. By having a choice in the subject matter you have the opportunity to take into account your likes and dislikes, opening up possibilities in how you respond to what you are drawing.

If the fruits or vegetables have a complex inner structure, cut them up. Oranges, tomatoes, and cantaloupes are good examples of this. If you use fruits or vegetables that have complex outer structures, there is no need to cut them up. The mushroom and onion in Figure 8 are examples of the latter.

Arrange the objects on a piece of paper, looking at the spaces between them as you do so. Take care not to have too much empty space surrounding the objects. Once you have an arrangement you like, keep the objects in this position. This arrangement will serve as the basis for your drawing composition.

Work large as you draw. Draw only the shapes that you see—no values or shading. Vary the heaviness of lines by using the different marking pens.

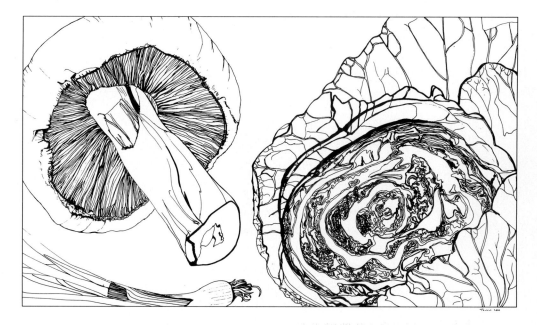

Fig. 8 *Contour drawing of vegetables with complex structures*

Do a contour drawing of the objects. Draw the outer and inner con-
tours. You may draw only portions of each object or the entire object.
Work very slowly and look closely.

Suggested time allowed is four to six hours.

✠ REFINING YOUR SKILLS

Drawing Composition and Touching the Edges of the Picture Plane
In every drawing you must consider the composition of your drawing as
you arrange the shapes within the picture plane. It is important to ener-
gize the entire space within that rectangle. This means that you activate
the drawing with the marks you make. By doing so, you give the person
who looks at your drawing something to hold his or her attention as the
eye travels throughout the drawing. As you develop your drawing skills,

you will understand more fully what this means. For now it is sufficient to understand that in some way you need to fill the page with shapes.

If you touch or nearly touch three or four edges of the picture plane with the drawn image, your drawing should be large enough and should cover enough of the area of the rectangle to result in a satisfactory composition.

At this point, keep two thoughts in mind when considering drawing composition. First, you don't want the bulk of your drawing to be in one part of the picture plane, with relative emptiness in the other. Second, you can use your intuition to determine if a composition is working. You know more than you may realize about arranging elements in a harmonious way.

Composition is a complex element in drawing, and as I said earlier, you will learn more as you work further. Nevertheless, it is important to consider it even at this stage of the learning process. By following the simple suggestions mentioned earlier, you will give your drawing the successful structure it needs.

Improving the Quality of Lines

The importance of line quality was mentioned in Chapter 2. This will continue to be a key factor in drawing. Keep in mind that lines should be smooth and flowing. Don't pick up your pen any more than is necessary. Using continuous lines helps to create a graceful quality in the drawing. The student drawing of onions (Figure 9) shows how graceful and lyrical this type of line can be.

In addition, now you should use the varying sizes of pens. Doing so will give you a variety of line thicknesses, making your drawing more complex and descriptive of the subject matter. When you make decisions as to which pen to use, look at the subject matter to judge when and where to use thicker or thinner lines. If a line looks heavier or denser than others, this would be one to draw with a thicker pen. Likewise, if a line feels more delicate and light than others, here would be a place to use a finer pen. As your drawing progresses you will see the effect of doing this and will know more readily where to use the different pens.

You will get some degree of dimension and value by treating lines in this way. Even though you are using contour and not value, this variety

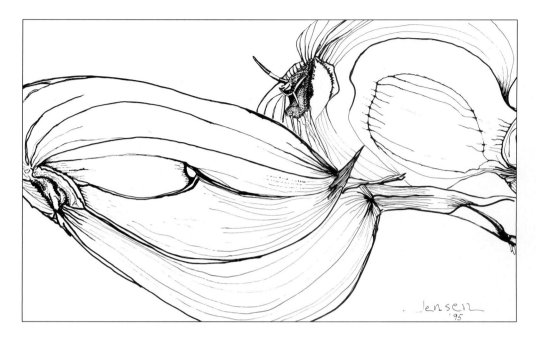

Fig. 9 *Contour drawing in which continuous lines create a graceful quality.*

of thickness in lines will create a sense of light and dark within the draw-
ing, thus giving it a subtle sense of depth. In Figure 10, varying thick-
nesses of line give the pieces of pomegranate a three-dimensional quality,
making it appear as if some parts of the fruit are closer to us than others.
Form is the shape, structure, and volume of actual objects in our environ-
ment, or the depiction of three-dimensional objects in a work of art.
Three-dimensional form is form that conveys a sense of height, weight,
and depth.

Remember that you are working only with lines and avoid the tempta-
tion of filling in shapes with black. Blackening in areas will create a visu-
ally heavy spot in the drawing that will dominate the other elements and
throw the composition off balance.

How to Correct When You Can't Erase

Again you are faced with the dilemma of having a marking pen that does
not erase. You will undoubtedly find that you have the urge to change a
mark. If this becomes overwhelming, you can draw over the lines to cor-

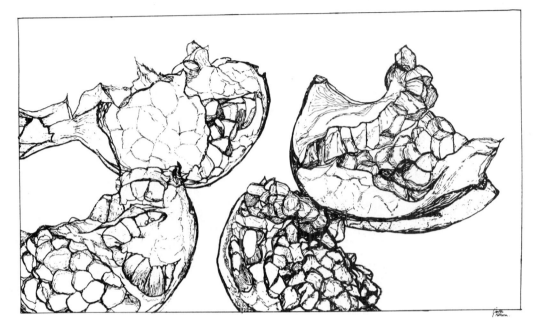

Fig. 10 *Varying thicknesses of line provide three-dimensionality.*

rect them. Do so delicately so that the marks are not too heavy-handed. Otherwise, just move on to the next shape. When you finish the drawing you will see that these "errors" that you made are not noticeable and that the entire drawing reads clearly despite them.

The main thing you need to do to assure that your drawing is as sensitive and representative of the subject matter as possible is to look closely. The more you develop your ability to look, the more accurate your drawing skills become. For every shape you draw, look closely. This requires that you work slowly and concentrate.

Of course, a sensitive and accurate drawing of the subject matter can take many forms. You are not doing a photographic rendering with that type of visual recording. You are doing a drawing, and there will be many interpretations of the subject matter. This is part of the beauty of drawing. You will see that as varied as they are, each drawing, if carefully observed, will reveal a truth about the physical appearance of these objects. Compare Figure 7 and Figure 11. Obviously these are two different interpretations of the sunflower, and yet each drawing fulfills the assignment in an admirable way.

Fig. 11 *Closeup of a sunflower reflects individual interpretation of subject matter.*

❖ **SKETCHBOOK ASSIGNMENT**

Materials: Marking pens, sketchbook

Directions: Do a drawing every day. Date each drawing.

Do drawings in your sketchbook of complex natural objects. Draw the inner and outer contour shapes of these objects. Look closely, but work quickly. Don't use value in these drawings; work with various sizes of lines, using the different pens to do so. See Figure 12, Figure 13 and Figure 14 for examples of such drawings.

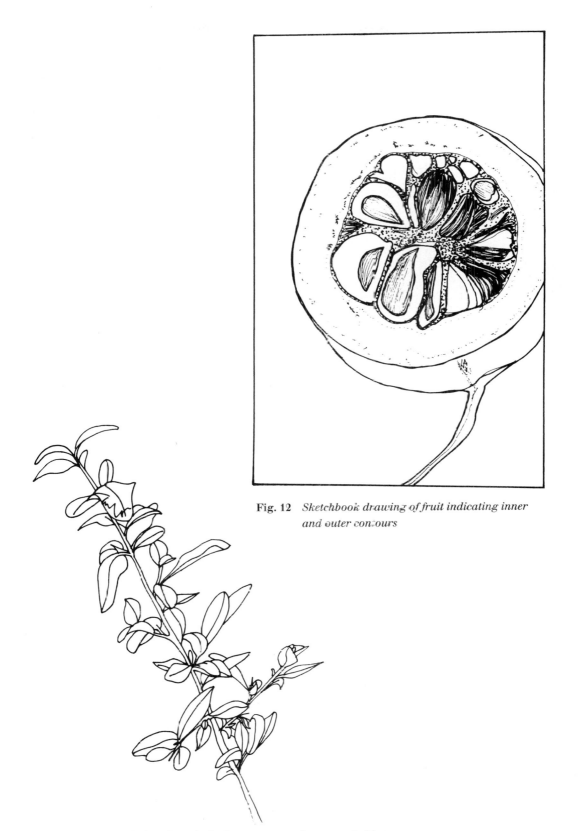

Fig. 12 *Sketchbook drawing of fruit indicating inner and outer contours*

Fig. 13 *Sketchbook drawing of a leafy stem, a complex natural object*

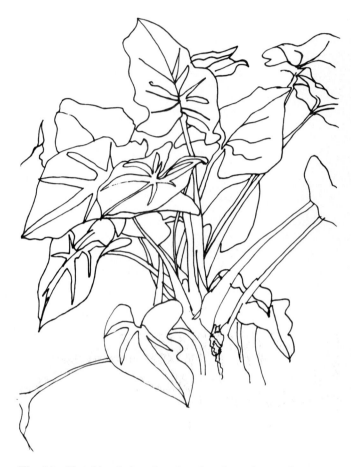

Fig. 14 *Sketchbook drawing showing close observation in a quick study*

❖ DRAWING CRITIQUE

What Are the Objectives?

As in Exercise 1, the main objective in Exercises 2 and 3 is to look closely and make marks based on what you see. In this case the task is more complicated because the subject matter itself is more complicated. What might seem at first glance to be an object made up of similar shapes, is in reality an object with many shapes of subtle differences. The closer you look at the object the more differences you see. Therefore keeping your focus and seeing shape relationships is a much more difficult task.

Line quality is important in this drawing, requiring that you keep lines flowing and sensitive to the subject matter. Because in these drawings you use varying sizes of pens, determining where to vary line thickness becomes a consideration.

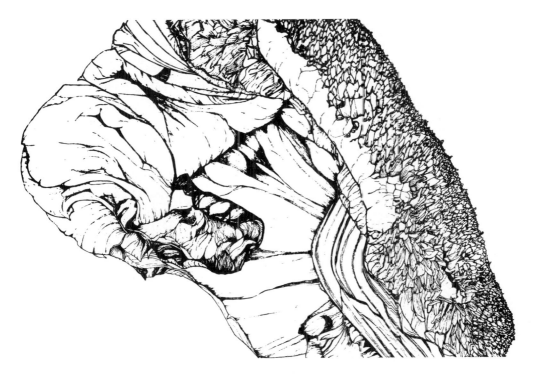

Fig. 15 *View of flower composed of a variety of shapes*

Finally, compositional choices are important in these drawings. The subject matter forces you to consider carefully how to arrange the image within the picture plane. Making satisfactory choices in this regard needs to be based on an intuitive understanding of compositional elements.

How Do You Determine if the Objectives Have Been Accomplished?
When you look at the drawings of these complex objects, you can determine if the person looked closely by noticing the shapes. The shapes should appear to be made individually with some irregularity and a sense of variety. In Figure 15, the student has chosen a view of the flower that increases the variety of shapes in the image. However, even in the upper part of the flower, he drew many different shapes, showing that he was observing the flower closely. The overall effect should be one of complexity and richness of detail. If shapes appear repetitious, mechanical, and calculated, then they are not well-observed. Each drawing should have an individual look to it. I call this a personal handwriting. It should be there in all of your drawings.

When you look for line quality in these drawings, keep in mind that they should be natural and rhythmic. The lines will appear to be unrestrained, with a somewhat liquid and graceful quality. They will also be of

varying degrees of thickness. This difference in heaviness, darkness, or thickness of line will tell you something about the dimension and form of the object being drawn. You will see that even though there is no value used, by distinguishing between shapes through this variation of line, an illusion of three-dimensional form is created. As defined earlier, three-dimensional form is form having a sense of height, weight, and depth.

How do you judge if the composition is working satisfactorily? If this is so, your eye will be drawn to all parts of the picture plane. There will be no areas that seem vacant. You will be led from one shape to another all through the picture plane. The drawing will have a sense of balance due to the distribution of shapes. In Figure 7, the shape of the flower dominates the picture plane and encourages us to look over all the varying shapes of the parts of the flower. But even the space of the drawing where there are no lines and shapes is important. The shape of that space is an effective balance to the shape of the flower, because our eye travels there to rest.

Questions to Ask Yourself When Discussing Drawings for Exercise 2 and Exercise 3

1. What does this drawing tell you about the subject matter that you might not have realized before? What physical and visual characteristics of the object are emphasized?
2. Is this drawing unique in some way? How would you describe that uniqueness? Is this drawing representative of the subject matter? Be specific when answering these questions by pointing out qualities in the drawing that serve to illustrate your observations.
3. How would you characterize the lines in this drawing? Use descriptive adjectives to talk about them.
4. Does the composition of this drawing lead your eye through the image or are there places where the path of your eye is halted? If the latter is true, how could this situation be improved?

Do you know that it is very, very necessary for honest people to re-main in art? Hardly anyone knows that the secret of beautiful work lies to a great extent in truth and sincere sentiment.

Vincent van Gogh

Chapter 4: Between the Lines: Positive Shapes and Negative Spaces

Because learning to draw is about learning to see relationships between things, it is important to see the spaces between shapes as well as the shapes themselves. In other words, whenever you draw something, you must also draw what is around it. We usually see our surroundings in a limited way. We focus on certain objects or subjects of our attention and we ignore others. There are simply too many stim-uli in our surroundings to do otherwise. However, what is a learned and efficient method for responding to our environment is something we must unlearn tem-porarily in the drawing process.

In this next step of learning to draw, you will focus on the spaces surrounding shapes, or the negative spaces. The **positive shape** is the shape of the object that is the subject of a drawing. **Negative space** is the area surrounding that shape. The relationship between positive shape and negative space is also called the **figure–ground relationship.**

Focusing in a Different Way

In this chapter's exercises, as before, you will be drawing shapes as they relate to each other spatially. Continue working in the same way as you have been, by draw-ing one shape, the shape next to that, and so forth. To distinguish positive shapes and negative spaces, look at the subject matter from a somewhat different point of view than you would ordinarily use.

Train your eye to look at the spaces between the shapes of the object. Look very closely at these shapes and draw them as carefully as you did the shapes in previous drawings. The visual relationships you are focusing on are those between one negative space and another.

Keep Your Attention on the Negative Spaces

Accuracy in representing the subject matter should not be of concern to you in this chapter. You should not draw the shapes of the subject matter at all. If you find that you are looking at or drawing the objects, re-focus on the negative spaces.

Look closely as you draw the negative shapes and draw them as accurately as you can. If you make an error in drawing, either draw over the line to correct it or ignore it and move to the next shape. In the finished drawing, these errors in

judgment will not be apparent, nor will they interfere with the success of these drawings.

The important consideration here is that you are changing the way you ordinarily look at things and seeing them from a different perspective. You can check yourself in this regard by standing back and looking at your drawing periodically to ascertain if you are drawing any detail in the subject matter. If you have drawn lines that show where one shape of the subject overlaps another, for instance, then you are looking at the wrong thing.

◆ **BASIC DRAWING EXERCISE 4**

Materials: Black marking pens of various sizes, including one with a broad tip

Inexpensive white drawing paper at least 24" x 36"

Subject Matter: A plant form with a complex system of limbs or leaves, tacked up on a black background.

Objectives: Your aim in this drawing is to look at the negative spaces between shapes and draw them as accurately as you can. By doing so, you learn how to see visual relationships from a different perspective.

Directions: Draw the rectangle of the picture plane. For this exercise, you will fill up the entire rectangle with shapes. Begin somewhere in the center of the subject matter and draw a shape that is between leaves or limbs. Continue by drawing the next shape you see between leaves or limbs. Continue in this way throughout the drawing, working your way organically through the picture plane.

Work large in scale. Draw only a portion of the still life.

Darken in the shapes as you go. Use a broad-tip marker to do this. Darkening in shapes allows you to easily keep your place in the still life. Doing this also gives you a clearer sense of the negative shapes and helps you to remain focused on them. When you finish you should have a silhouetted image of the still life. However, do not concern yourself with how much the drawing does or does not look like the subject matter. That is not the point of this drawing.

If you find that you are drawing leaves, limbs, or details of either, then you are approaching this problem incorrectly. Stop and re-focus on the negative spaces.

Suggested time allowed is three hours.

✣ REFINING YOUR SKILLS

Filling the Entire Picture Plane with Shapes

In Exercise 4 you need not think too much about composition if you fill in the entire picture plane with the shapes. The subject matter will be complex enough to allow you to do this with ease. In Figure 16 the artist obtained this rhythmic and energetic drawing composition simply by looking very closely at the negative spaces in the subject matter.

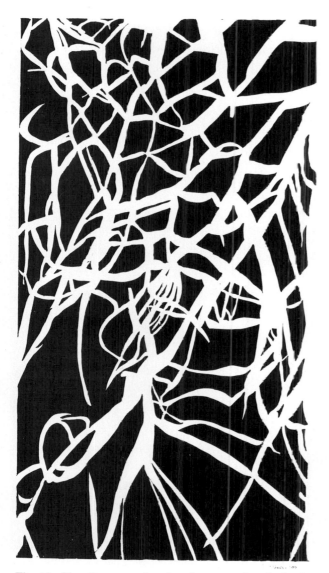

Fig. 16 *Negative-space drawing demonstrating rhythmic and energetic composition*

Maintaining a Slow Drawing Pace

Even in this relatively simple drawing assignment, it is important to work slowly. By training yourself to work slowly, you will also train yourself to look consistently before you draw. Because of this, your lines and contours of shapes will be more sensitive to the subject matter than they would be otherwise.

The Importance of Seeing Negative Spaces

This drawing exercise is important because it gives you another mechanism for measuring visual relationships and seeing the subject matter more clearly. By training yourself to see the spaces in between objects as well as the objects, you have the advantage of seeing the same line from two points of view. Often what you thought was accurate will prove not to be if you look at the negative space. In all future drawings you should use this tool to help you draw more accurately.

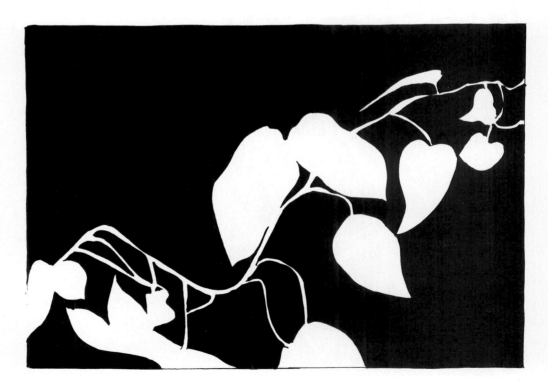

Fig. 17 *Negative-space drawing of leaves and stems*

❖ **SKETCHBOOK ASSIGNMENT**

Materials: Marking pens, sketchbook

Directions: Do a drawing every day. Date each drawing.
Do drawings of negative spaces. Choose complex natural objects
in your environment as the subject matter. Examples of such objects
would be plants, trees, bushes, and flowers such as you see in Figure 17,
Figure 18, and Figure 19. Fill in these negative spaces with black, leaving
the positive shapes of the objects white. Don't look at the positive shapes
as you draw.

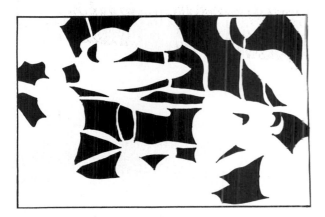

Fig. 18 *Negative-space drawing of natural objects*

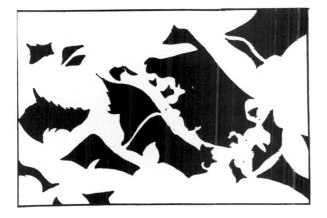

Fig. 19 *Negative-space drawing of natural objects*

Fig. 20 *Negative-space drawing silhouetting the subject matter*

❖ DRAWING CRITIQUE

What are the Objectives?

In these drawings, you looked at the subject matter in a different way than before. Here, you were not looking at the positive shapes of the objects but at the negative spaces in between them. The aim of this drawing was to draw these negative spaces and to darken them in, resulting in a silhouetted drawing of the subject matter (see Figure 20).

How Do You Determine if the Objectives Have Been Accomplished?

The main thing that you need to be certain of is that the drawing is of the negative spaces. How do you know by looking at the drawing that this is so? The drawing will have a degree of inaccuracy to it. This is partly because you are not looking at the subject matter, and partly because you are not used to seeing these negative spaces. However, this inaccuracy will not interfere with the final drawing. As you can see in Figure 21, the positive shapes of the leaves are generalized and don't describe leaf shapes in detail, yet the overall drawing has a complicated and visually interesting appearance because of the high contrast and the sensitivity of negative shapes.

Fig. 21 *Negative-space drawing of generalized shapes*

Another way to check to see if the focus is on negative shapes is to make certain that detail is not included in the positive shapes. Examples of detail would be lines indicating overlapping or lines indicating structure of positive shapes.

This drawing exercise is simple compared to others in this book. There needn't be too much discussion on results. Basically the process of doing the drawing is most important. As long as you understand now how to look at negative spaces when you are drawing, then you have accomplished your goal.

Questions to Ask Yourself When Discussing Drawings for Exercise 4

1. What is the importance of this exercise to the drawing process?
2. In what drawing activities would this exercise be useful?

The past is hidden somewhere outside the realm, beyond the reach of the intellect, in some material object which we do not suspect.

Marcel Proust
Swann's Way: Remembrance of Things Past

Chapter 5: Structure and Texture

As we continue, your ability to look closely and draw in response to what you see is increasing. It is important now to distinguish between contour lines, which describe the structure of objects, and those lines that describe the surface texture of objects.

Structure is the arrangement of parts in a form. Structural lines create the illusion of three-dimensional form and give us a sense of the physical presence of an object.

Texture is the surface character of a form. Textural lines describe patterns on the surface of the objects and give us a feeling of the tactile quality of the object. Both of these qualities are important, but it is necessary to distinguish between them for the sake of visual clarity. For this reason, in your drawing you should indicate structural lines by making them heavier or darker than textural lines. As you can see in Figure 22, the darkest lines indicate the structure of the celery, and the lighter, more delicate lines describe its surface patterns and textures.

Looking Closely at Structure and Texture

Looking closely and making marks based on what you see are still primary objectives in the exercises of this chapter. However, because now you are drawing contour lines that define structure and texture, your task is more complex. You must look closely at structural lines and draw them carefully because an error in the direction of a line will convey misinformation about the object's form. You must look closely at textural lines and interpret them in such a way as to show surface qualities of the objects. You may even want to use a magnifying glass to get a closer look. In the drawing of shells (Figure 23) the darker structural lines show us the form of the shells. Even though these shapes are complex and difficult to draw, the student observed them carefully and sensitively defined the basic shapes of all three shells. She described the shells' surfaces with a variety of lines indicating texture. There is a richness of detail to this drawing and also a clear sense of the structural integrity of each object.

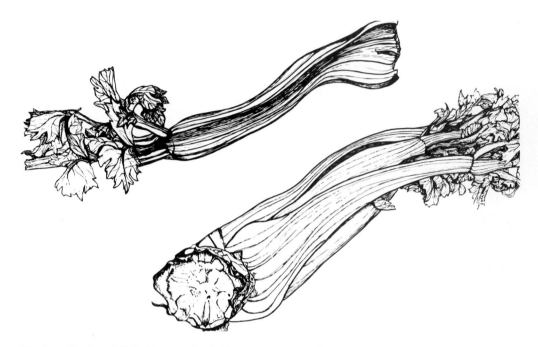

Fig. 22 *Dark and light lines used to indicate structure and texture*

Fig. 23 *Dark structural lines used to indicate forms of shells*

✦ BASIC DRAWING EXERCISE 5

Materials: Black marking pens of various sizes

Inexpensive white drawing paper at least 24" x 36"

Subject Matter: Three or four natural objects of the same type with simple, yet distinct shapes and obvious surface patterning or texture. A good example of subject matter would be seashells. They have clearly visible structures that are easy to interpret with lines, and they usually have textured surfaces offering a richness of detail to observe.

Objectives: In this drawing you learn how to represent the structural and textural lines of the objects and convey a sense of form and a richness of detail. You also will set up the composition of your drawing by arranging a simple still life of the objects.

Directions: Arrange three or four natural objects on a piece of paper that is approximately the same shape as the rectangle of your picture plane. Once you are satisfied with the arrangement, leave the still life in a stationary position next to your drawing board. Obviously you will be looking down on these objects to draw them. If you pick up the objects for a closer look as you are drawing, return them to their place in the still life.

Draw the rectangle of the picture plane. Begin drawing one of the objects at the outer contour edge. Working your way toward the center of this object, draw the shapes and lines that you see. Don't draw the entire outer contour of the object at first. Only draw small parts of it at a time. Return to the outer edge and repeat this process until you are finished with the object. Continue by drawing the rest of the objects in the same manner. Work large, blowing up the objects in scale.

You can draw a part or the whole of objects, but in either case the image must touch or almost touch all four edges of the picture plane. Look closely and draw varying widths and types of lines to represent structure and texture.

Even though the image will exhibit a sense of light and dark due to the differing weights of lines, you still should not be using **value**, the many observable tones from white to black or light to dark. As you can

Fig. 24 *Varied line densities used to indicate surface patterns on shells*

see in Figure 24, various types and densities of lines indicate surface patterns on the shells, thus creating lights and darks in the drawing, even though the student has not been trying to use value.

Suggested time allowed is six to eight hours.

◆ **BASIC DRAWING EXERCISE 6**

Materials: Black marking pens of various sizes
Inexpensive white drawing paper at least 24" x 36"

Subject Matter: Two different natural objects with complex structures and surface textures. Good examples of such objects would be driftwood, feathers, bones, leaves, and seed pods. When selecting objects, look at them in terms of shape, texture, and structure and allow these factors to govern your choices.

Objective: The objective in this drawing exercise is to describe the structural and textural elements of the objects. The subject matter has a complexity of structure and diversity of texture that you convey in the drawing.

Directions: Set up a simple still life using the objects you have selected, one that loosely establishes the composition of the drawing. Begin by arranging the objects on a piece of paper that is the same shape as your picture plane. Move the objects around until you feel you have a grouping that will work as a basis for the drawing's composition. Leave this still life in place while you draw from it.

Draw the rectangle of the picture plane with a marking pen. Focus in on the still life, working large and touching or nearly touching all four edges of the picture plane with your finished drawing. Draw the objects in part or in their entirety.

Look closely at the shapes and surface textures of these objects and draw the shapes and lines that you see. Some lines will define structure and some texture.

Suggested time allowed is four to six hours.

✛ REFINING YOUR SKILLS

Positioning Objects with Composition in Mind

Because in this chapter you are working with natural objects that you arrange yourself, the possibilities for composition are many. For this reason you need to position the objects with the idea of composition in mind. Your still life serves as a compositional sketch.

Place the objects on a piece of paper that is the same shape as your picture plane. This means that the ratio of height to width will be approximately five to eight. Move the objects around on the paper until you are satisfied with the arrangement. Use your intuition to decide what works. I say this because we all have a good, innate sense of visual organization. If you relax and thoughtfully move the objects around, you will probably come up with a workable solution.

Here are a few suggestions that may help:

(1) Look at the negative spaces. There should be a dynamic between them and the positive ones. They should interact visually. Above all, the negative spaces should not dominate the positive ones. In Figure 25, the placement of objects within the picture plane works very well. The posi-

Fig. 25 *Effective placement of objects within the picture plane*

tive shapes and negative spaces interact with each other and create a successful composition that is balanced and interactive.

(2) Take note of the relationship of objects to each other. Here too there should be visual interaction, with the objects complementing each other. They should be similar enough in scale and shape to give the drawing a unified look. They should look as if they are meant to be grouped together. Figure 26 is a good example of this. Even though the chosen objects are different in scale, they are similar enough in shape to relate well compositionally.

(3) When you place the objects, think of them as markers in a visual journey. There should be a pathway through the still life as you look from one object to another. This pathway energizes the drawing throughout with lines and shapes. In Figure 27, our eye moves throughout the drawing as it first travels through the rhythmic, linear leaves and stems on the left and then moves to the larger vertical shape on the right where it visually traces the different shapes and textures it sees there.

(4) Remember to touch or almost touch all four edges of the picture plane with the finished drawing. This automatically makes your job somewhat easier because it guarantees that the image will cover most of

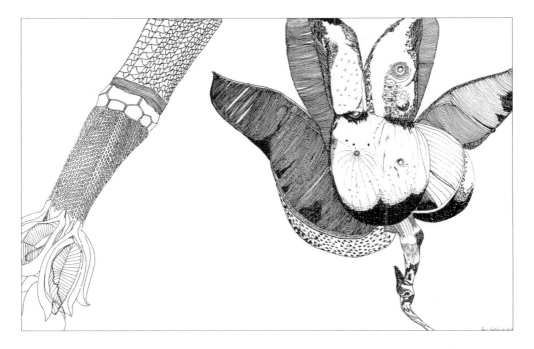

Fig. 26 *Complementary objects relate well compositionally*

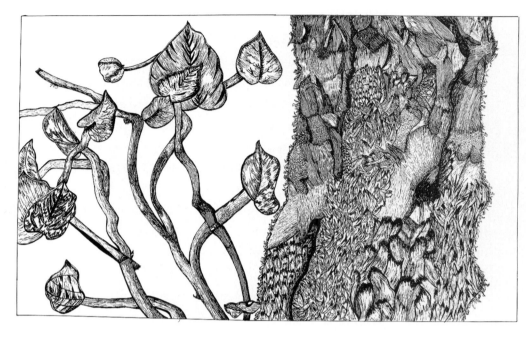

Fig. 27 *Lines and shapes create a visual pathway.*

the picture plane, eliminating the possibility of having large parts of the drawing filled with empty space. Also, you don't need to draw the objects in their entirety, which gives you more flexibility in how you group them.

Looking at Lines and How They Function

All that you have learned about lines still applies. Lines you draw should reflect how closely you are observing the subject matter. When you look at the lines and shapes in the objects, determine how they will function as lines in your drawing. If lines are to define structure, they should be heavier and denser than those that define texture. You can convey this by either using a broad pen or by making several thin lines next to each other. If lines describe texture, they will be more delicate and lighter than structural lines. Lines defining texture will also be varied in their appearance, in order to represent the various surface qualities of the objects. Look closely at the surface to determine what your choices will be. Some textures require short, straight lines, while others might call for curved lines. Try different types of line; experiment a little to find what effects you can get. Look again at Figure 27 to see textures described in different ways.

Avoid filling in shapes with black because doing so will flatten out the drawing and overpower the subtlety you have developed in other parts.

Maintaining a Slow Pace

It is important to work slowly. Doing so will improve your ability to see the lines and shapes in the objects. Even though this subject matter is simpler in some ways than previous ones, it is in other ways more demanding. Because of the simplicity, it becomes even more critical that you see the direction and shape of lines so that you may create a convincing image in response. You also need to see the relationship of shapes to each other. The challenges are greater in terms of measuring with your eyes. Working slowly increases your ability to concentrate on these things.

Using Textural and Structural Lines with Varying Weight and Density

You are still working with contours, not values. You will notice, however, that as you develop textural and structural lines with varying weight and density of lines, you begin to get a sense of light and dark in the drawing and subsequently of volume. Although you are not using value now, the understanding you gain from doing these drawing exercises will help you when you work directly with value exercises later in this book.

❖ SKETCHBOOK ASSIGNMENT

Materials: Marking pens, sketchbook

Directions: Do a drawing every day. Date each drawing.
Do drawings in your sketchbook of complicated natural objects. Get a sense of the structure and texture of these objects in the drawings. These should be quick sketches. (Figure 28 and Figure 29)

♣ DRAWING CRITIQUE

What Are the Objectives?

The drawing exercises in this chapter continue objectives of earlier drawings. You are still improving your ability to look closely and use what you observe as the basis for the marks you make in your drawings. You also are concerned with the quality of your lines, making sure that they represent the subject matter sensitively.

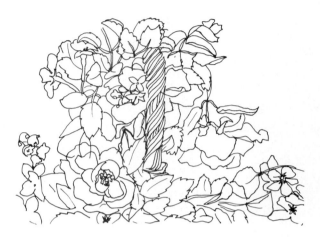

Fig. 28 *Sketchbook drawing capturing structure and texture*

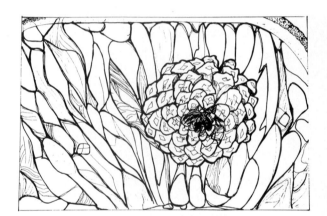

Fig. 29 *Sketchbook drawing capturing structure and texture*

Composition has become a greater concern with the last two drawings. Because you constructed a composition sketch with the arrangement of your still life, you had to focus more directly on compositional issues. You had to arrange more than one object and take into consideration the negative spaces. Your choices determined whether the drawing composition was successful.

Also, when making lines you had to consider their purpose in the drawing. To some extent, this purpose determined how you drew them.

Structural lines were expressed differently than textural ones. Interpretation of what you saw was influenced somewhat by your understanding of this purpose.

How Do You Determine if the Objectives Have Been Accomplished?
Apply everything that you have learned up to this point when looking at this chapter's drawings. There are also some new factors to consider.

The emphasis on composition is greater now due to the fact that you had to arrange the objects in a still life. How do you look at a finished drawing and determine if compositional choices are successful?

The first thing to look at is the relationship of positive to negative shapes. The most common mistake that students make with composition is failing to consider the negative spaces as part of the composition. You are frequently only aware of the objects. Often the result is that the negative space dominates the drawing because there is too much of it. When you look at these drawings, the negative spaces should integrate with the positive ones and balance out the composition. In Figure 27 the negative spaces and positive shapes integrate with each other, thus creating a balanced composition.

Next, look at the positive shapes in relation to each other. They should seem to go together. There should be a consistency in size and shape that unites them.

Moving your eye from one shape to another should lead your eye throughout the drawing, with each shape being a marker in this visual journey. The composition in Figure 25 leads your eye from shape to shape throughout the drawing.

In these finished drawings, use of lines becomes more complex. They not only define the contour edges of shapes, but they also define the structure and texture of the objects. Keeping this purpose in mind, you had to use lines that conveyed this in the drawing. You should be able to perceive the structure and form of the objects because of the way they are described with line. The shapes should even begin to take on a three-dimensional quality. This is happening in Figure 30 where a difficult subject matter of broken rocks is translated effectively in lines and shapes that reveal a sense of the objects' three-dimensional form.

Also, you should get a sense of the surface of the objects and the way they might feel if you were to touch them. The overall effect would be one of detail, as if you were looking at these objects up close and could see

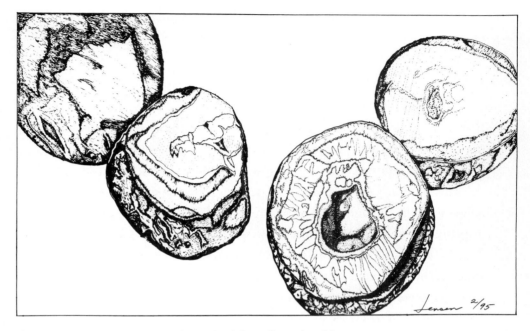

Fig. 30 *Lines and shapes reveal a sense of three-dimensional form.*

every aspect of the texture and pattern of the surface. The form on the right in Figure 27 is a good example of describing texture.

Questions to Ask Yourself When Discussing Drawings for Exercise 5 and Exercise 6

1. Is the composition balanced and unified? Are the objects large in comparison to the negative spaces, or small? Do the images fill the page?

2. Do the shapes have a harmonious relationship with each other? Are there any discrepancies in this? If so, do these differences support or do they disrupt the composition?

3. Does your eye move easily through the entire drawing, or does it get caught in one area, making it difficult to move along?

4. Do you get a sense of the volume of the objects? Does their structure seem believable? Are lines weighted differently to accomplish this?

5. Is there a sense of texture in the drawing? What kinds of lines make up this texture? How would you describe the surface texture of the objects?

6. Do you get the sense that the subject matter was well-observed and if so, what tells you this? If not, what tells you this?

7. Do you believe that this drawing was done with commitment and care? What tells you this? Where do you find these qualities lacking?

The more you wish to describe a Universal the more minutely and truthfully you must describe a Particular.

Brenda Ueland
If You Want to Write

Chapter 6: Spatial Depth and Texture

In the last chapter you learned how to distinguish between lines that describe structure and those that describe surface texture. In this chapter we look at the subject of texture further. In the subject matter for this chapter's drawing exercises there are many different textures that need different systems of lines to represent them. The shapes and lines that you see in the forms of the subject matter give you information on how to go about drawing these textures.

The still life for these drawings is complex, with many shapes overlapping each other. When drawing them it is necessary to separate the shapes visually, by emphasizing some more than others. Doing this creates an illusion of spatial depth, allowing us to perceive that some shapes are closer to us than others. In your drawing, you will learn to impose order on a very complicated still life by differentiating between the various textures and shapes.

Looking Closely to Differentiate Textures and Shapes

Looking closely still serves as the basis for what you draw. The subject matter for these drawings contains objects having different textures and shapes. You need to differentiate between them in your drawing. To do this, look closely at the textures and find various ways of representing them with lines. Also, look carefully at contours of shapes and judge where to make lines denser or heavier in order to separate them spatially.

This complicated subject matter requires that you measure and compare many visual relationships. The identity of figure and ground is constantly shifting, as you focus first on one shape and then on another. These drawings allow you to develop your ability to maintain control over an intricate subject matter and to concentrate your attention without distractions.

You will probably notice that the drawings in this chapter are similar to the first one in this book, due to the subject matter. I think by comparing that first drawing with these, you will see that your ability to draw what you are observing has improved immensely.

✦ **BASIC DRAWING EXERCISE 7**

Materials: Black marking pens of various sizes
 Inexpensive white drawing paper at least 24" x 36"

Subject Matter: Complex still life with many overlapping objects that have obvious textural qualities and patterns. All students work from the same still life.

Objective: In this drawing you will look closely at textures and shapes in a still life that your instructor sets up. Your goal here is to find ways of differentiating between textures and of making shapes stand out from each other spatially.

Directions: Focus in on a part of the still life that you select as the subject matter for your drawing. Find a viewpoint on the still life that is visually interesting to you. Make certain that you are always in the same position in relation to the still life.

In your drawing, enlarge the scale of the images. Touch all four edges of the picture plane with the finished drawing.

Look closely at the contours and surface textures of the objects as you draw. Note that in this still life, the position of positive and negative spaces shift, depending on where you are focusing at the time. Vary the width of lines to distinguish the structure of objects and to create a sense of spatial depth. In particular make a distinction between what is object and what is surface through your definition of outer contour edges.

Differentiate between textures by using different systems of lines to represent them. Differentiate between objects by varying the width of contour lines. In Figure 31, the student artist differentiated textures by using different types of marks throughout the drawing. She also created a subtle illusion of spatial depth by darkening lines at contour edges of shapes.

Suggested time allowed is six to eight hours.

✦ **BASIC DRAWING EXERCISE 8**

Materials: Black marking pens of various sizes
 Inexpensive white drawing paper at least 24" x 36"

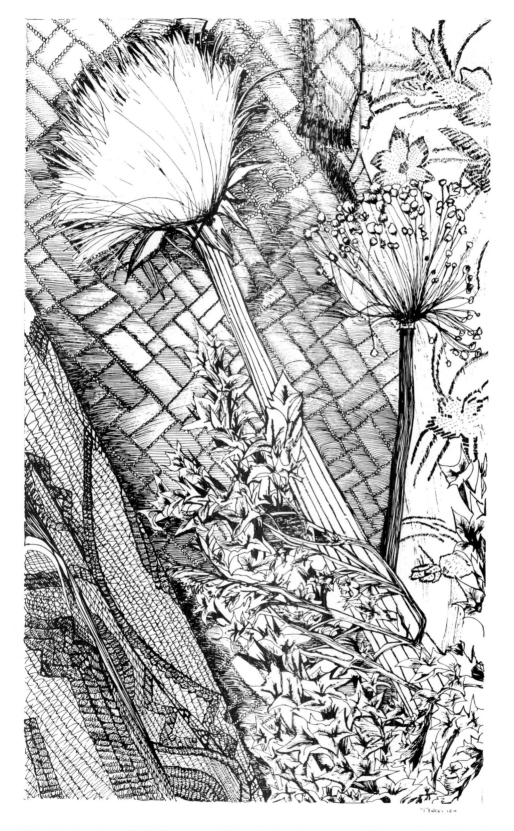

Fig. 31 *Complex still life illustrating differentiation of textures and illusion of spatial depth*

Subject Matter: Two natural objects with obvious texture set on a textured or patterned surface. Choose objects that appeal to you visually because of their textures and shapes. The objects should contrast with each other texturally. Examples of such objects would be wooden boxes, woven baskets, bird feathers, plant forms, and heavily textured cloths.

Choose a background surface for the objects that has a textural or patterned quality. Find a texture that is challenging to draw. Textured surfaces such as gravel, wood, grass, brick, and patterned cloths work well for this drawing.

Objectives: In this drawing you will observe the textures in a complicated still life. Your aim is to convey this complexity of surface and also to impose an order on the complicated subject matter.

Directions: Choose objects and surface that appeal to you visually. A large part of the impact of your drawing comes from your choice of subject matter. If you choose things that engage you, the drawing will undoubtedly be more successful.

Arrange the objects on the patterned or textured surface. As you do so, think about composition and work toward a dynamic relationship between the shapes and textures. Leave the still life in place as you draw it. Keep in mind that your position in relation to the still life should remain consistent; otherwise, the visual relationships will change.

Draw the picture plane. Touch all four edges with the finished drawing. Work in a large scale. Look closely at the contours and surface textures of the objects as you draw. Do not use value in this drawing.

✛ **REFINING YOUR SKILLS**

Ordering a Detailed Composition

The subject matter for the drawings in this chapter is complex. Because of this, your compositional concerns are somewhat different from those in previous drawings. You are drawing a still life that is dense and filled with many objects. There will be more than enough images to fill the picture plane, so you don't need to think about empty spaces. Instead, the opposite is true; you must think now about how to give order to such detailed, complicated imagery.

Returning to the idea of a visual pathway, think of orchestrating the arrangement of shapes and textures so that they lead the observer's eye through the drawing. You do this by making some lines darker, thicker, or more dense than others. When deciding how and when to do this, there are two considerations to make. One is the depth in the drawing. By bringing some objects forward and placing others behind, you create a spatial depth in the drawing. If you want to bring an object forward, darken its outer contours in comparison to other shapes. The other factor to consider is the contrast between outer contours of objects and inner shapes or textures. By emphasizing the outer contours, you give the image volume, thus clarifying the structure of the drawing and putting the surface detail into a context. In Figure 32, shapes come forward or recede depending on the definition of contour edges. There are several complex textures in the drawing, creating the appearance of rich detail in the shapes. However, the image is not confusing because of the various ways this student described the different features.

Creating a Variety of Textures with Line

We have discussed the quality of lines and how lines should reflect your close observation of the subject matter. You have seen that by varying the

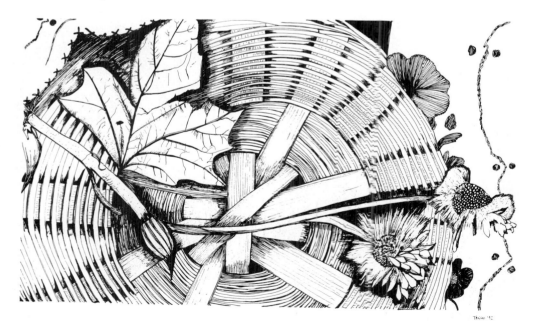

Fig. 32 *Differentiation of contour edges creates illusion of spatial depth.*

thickness of lines you can create a sense of volume and spatial depth in your drawing. The drawing exercises in this chapter focus on considerations that were introduced previously as well as on a new issue. Now, in order to represent the variety and complexity of textures in this chapter's still-life drawings, you need to change the types of lines you make accordingly. By looking closely at the different textures you can draw an assortment of lines and shapes that will represent those you see. Even though you are drawing from observation, it is time to exaggerate for the purpose of creating an illusion of texture. Figure 33, Figure 34, and Figure 35 show a few of the many ways that you can use lines to create a variety of textures. Determining how to do this can vary from person to person also, leaving room for differing interpretations of the same subject matter.

A Shifting Field of Positive and Negative Spatial Relationships

In these drawings the subject matter is so complex that you have to establish a focus and control over what you are looking at in order to draw perceptively. One way you can do that is by looking at the overlapping forms and seeing the positive-negative relationship between them. By seeing one layer of the still life as the positive shape and another as negative, you

Fig. 33 *Varied lines create an illusion of texture.*

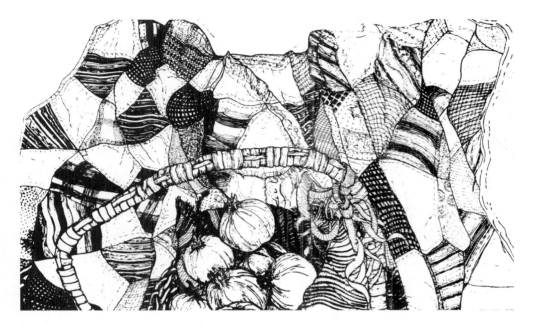

Fig. 34 *Varied lines create an illusion of texture.*

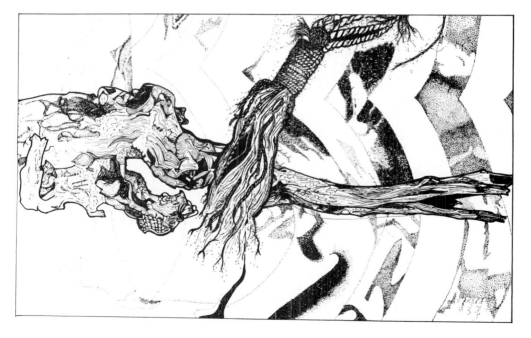

Fig. 35 *Varied lines create an illusion of texture.*

can draw more accurately. In other words, you are not drawing a succession of objects now but rather a field of positive and negative shapes that can shift position, depending on your focus at the time.

❖ SKETCHBOOK ASSIGNMENT

Materials: Marking pens, sketchbook

Directions: Do a drawing every day. Date each drawing.
 Draw complex natural objects placed on textured grounds. Make these sketches quickly. Distinguish between the objects and the ground. Try to achieve a tactile quality in the sketches (see Figure 36 and Figure 37).

♣ DRAWING CRITIQUE

What Are the Objectives?
In these drawings you had to look at a complex arrangement of forms, many of which have obvious textural qualities. You were to observe the

Fig. 36 *Quick sketch distinguishing objects and ground*

textures closely and find systems of lines and shapes that represented the different textures. You were also to distinguish forms from one another by varying the lines in some way. By doing this you were to create a spatial dimension to the drawing.

Another consideration in these drawings was composition. Control over composition depended on the creation of emphasis through line of some parts of the still life over others.

How Do You Determine if the Objectives Have Been Accomplished?
To determine if finished drawings fulfill the objectives here, consider the number of textures and their complexity. The drawing should have many different lines and shapes to represent texture. Use your sense of touch to judge the success of these descriptions of texture. The varieties of lines in Figure 38 describe a richness of texture that conveys a tactile quality to the eye.

Similarly, use your perception of spatial depth to determine if the drawing successfully creates illusion. Do some objects appear to be closer to you than others? Do you get the feeling you could reach back into the drawing behind the surface of the picture plane? Refer back to Figure 31 and Figure 32 for examples of this.

Fig. 37 *Sketchbook drawing showing texture*

Fig. 38 *Varieties of line describe a richness of texture to convey a tactile quality.*

Fig. 39 *Line density and textural patterning help to organize a composition.*

When judging composition, apply the same criteria you did in previous drawings. Your eye should glide easily through the drawing as it moves from one part to another smoothly. There should be a sense of order to the drawing due to the emphasis of some elements over others. In Figure 39, the student organized the composition by varying the amount and density of lines within shapes. The overlapping front shapes are simple, with no interior, textural lines. The central image is denser with line and recedes as a result. The play of shapes back and forth, as well as over the surface of the drawing, engages the eye in a rhythmic path through the drawing.

**Questions to Ask Yourself When Discussing Drawings
for Exercise 7 and Exercise 8**

1. Is there an illusion of texture in the drawing? Is this conveyed in a number of different ways? Is the texture convincing? Is the texture inventive?
2. Do you feel that you can visually move behind the picture plane? Do the forms represented appear to have volume?
3. Is there any part of the composition that is a problem area? If so, what creates this visual confusion? How would you describe the visual pathway in the drawing?

We do a lot of looking: we look through lenses, telescopes, television tubes. . . . Our looking is perfected every day, but we see less and less.

Frederick Franck
The Zen of Seeing

Chapter 7: Introduction to Value

Up to this point we have been working with lines and contours, shapes and edges, texture and form. We are ready now to begin exploring value.

The use of value is an important tool in drawing. Value in drawing indicates the inherent lightness or darkness of forms. It also models forms and gives them a sense of volume or three-dimensionality. Differentiation of value relationships gives a sense of the relative distance between forms and creates an illusion of spatial depth. Finally, value shows the effect of light falling on forms.

The medium that we will use to learn about creating value is charcoal. Several other materials will help you to manipulate the charcoal and attain the desired effects. In this chapter, we will go over these materials and their uses and do one exercise that will introduce you to value and help you to see it clearly.

In this book, the method of drawing with charcoal that you will use involves both an additive and subtractive process. An **additive process** is one in which you add materials to the drawing surface as a way of developing the image. A **subtractive process** is one in which you take away materials to develop the image.

To put it simply, in order to get the darker values you will add varying amounts of charcoal to the surface. The more charcoal you apply, the darker the value you get. To obtain lighter values, you erase charcoal from the surface. The more pressure you put on the eraser, the lighter the value you obtain. The white of your paper will not show in the final drawing. You will begin each drawing with a **ground** that is a middle-value gray. A ground is the prepared surface on which you draw. In this case the ground consists of layers of charcoal.

Of course there are many ways to vary this adding and taking away of charcoal. The methods you develop can be diverse and complicated, revealing your own unique ways of creating an image.

A Personal Approach to the Medium

The development of your particular drawing style with charcoal will, of course, take some time. Don't expect to know from the beginning how to approach this; this is a learning process. Your abilities develop through experience. It is only with

the actual making of the drawing that you can judge the results and make changes accordingly. The way you learn to use the materials will evolve gradually.

This book doesn't give you truisms for drawing with charcoal, techniques for getting specific effects, or easy solutions of any sort. Instead, it provides a focus and direction for practice that opens up the process of discovery. You will come away from this experience with an approach to drawing that is your own.

I hope you will agree that this is an inherently more satisfying and meaningful approach. Not only will you learn how to create value with charcoal, but you will have a sense of accomplishment and you will be better able to apply what you have learned to future work.

Development of the Drawing Surface

One of the primary concerns you will have as you learn to create value is the development of the drawing surface. The way in which you move the materials around on the surface of the paper describes three-dimensional form, spatial depth, light, and so forth. Also, the particular ways that you develop the surface express your individuality in these drawings. As you will see, everyone has a slightly different way of handling charcoal.

Learning to build up the drawing surface means learning how to add and remove the charcoal from the surface, how to incorporate lines and smoothed areas, how to blend in different ways, and how to define edges of shapes. Even though at first you may not know exactly how to approach these steps, as you get more practice with them you will learn how to look at surfaces and determine what the drawing needs.

Building up of surfaces takes time. It is a recursive process that moves back and forth between adding material to the surface and taking it away. The surface consists of layers and becomes more and more refined or detailed as you work.

The way of working now is different from what you were doing with the pen lines in previous chapters. Here, you can always change what you have drawn. It is important that you think of what you are doing in terms of change. Don't think of this change as erasing something or as correcting errors that you have made. Think of it as refining and clarifying the image.

Materials

As I mentioned earlier, you will be using different materials now as tools for drawing. The following is a list of these materials and a brief description of their uses. Feel free to experiment with them and expand their uses.

- **Compressed Charcoal.** Compressed charcoal is used to put down a ground and to draw most areas of dark value.

- **Charcoal Pencils.** Charcoal pencils come in different degrees of hardness and softness as indicated by numbers. You need at least three variations of density, such as HB, 2B, and 6B. These pencils are used to draw prelimi-

nary contours. They are also used to define edges and whenever there is a need for more detailed or delicate work. Sharpen pencils with a small metal pencil sharpener. Keeping your pencils sharp allows for the greatest control of line.

- **Kneaded Eraser.** A kneaded eraser is used for erasing as well as drawing. The first time it is used, stretch it out as far as possible and then roll it into a ball. Subsequently, whenever it needs cleaning, repeat this procedure; the eraser will clean itself.

 To erase with it, gently rub the surface of your drawing. You may break off small pieces of the eraser for getting to smaller areas in the drawing. To draw with this eraser, use it as if it were a piece of charcoal. Draw in light areas by putting more or less pressure on the eraser. The more rubbing and pressure you apply, the lighter the surface will become. You can also use the eraser to even out the surface of the drawing and to blend together areas of value.

- **Pink Pearl Eraser.** A Pink Pearl eraser picks up light more easily than the kneaded eraser. It is not possible to be as subtle with it. However, at times, when you want a light area, it will often be the most efficient tool.

- **Pink Pearl Eraser Pencil.** This eraser can be used for drawing in detail, erasing small areas, blending values, and so forth. You can sharpen it in your pencil sharpener, so that it gets a relatively fine point.

- **Flat Bristle Brush (at least 1" wide).** The brush is used to remove eraser bits, excess charcoal, and to softly blend areas of value.

- **Cloth.** A soft cotton cloth is used to smooth out a ground, to blend areas of value, and to even the surface of a drawing.

- **Blending Stomps.** Cardboard blending stomps are shaped like pencils. You should have several sizes because you will need to use them in different ways. They can be used to blend and soften drawn lines and edges. They can also be used to draw in subtle lines and areas of value.

- **Masking Tape.** Masking tape is used to cover the part of your paper that borders the picture plane. By covering this area with tape, you protect it from the charcoal. When you finish drawings, remove the tape, leaving a clean white edge surrounding each drawing.

- **Sandpaper Block.** The sandpaper block is used to sharpen pencils or charcoal sticks to a finer point.

- **Fixative Spray.** By spraying drawings with fixative you can prevent the charcoal from smearing to some extent. Spray fixative on a drawing according to the directions on the can. Even though some fixatives are workable, meaning that you can work on a drawing after spraying it, you usually cannot erase the light areas completely after applying fixative.

 Do not spray inside buildings or any other enclosed space. *This is a toxic substance.*

- **Arches Paper.** Use this paper (or any other 100 percent rag paper with a slight tooth or surface texture) for charcoal drawings. It is a substantial paper that will withstand a lot of erasing without damage to its surface.

Seeing Value Relationships

Value is the element that allows us to perceive light and form. As would naturally follow from what you have done already, looking is important in the process of drawing value. You must learn to see the values and to see how they blend into and differentiate from each other.

To help you become accustomed to seeing value, the basic exercise in this chapter will be to construct what is called a value scale. This exercise serves as an introduction to value and to the use of charcoal.

It is not necessary to discuss these drawings in critique or to practice in your sketchbook. Therefore this chapter does not have a sketchbook assignment, discussion of critique, or critique questions.

✦ **BASIC DRAWING EXERCISE 9**

Materials: Charcoal sticks and pencils, Arches paper, blending stomps, cloth, and erasers

Objective: In this exercise, you will draw a value scale progressing from black to white, with five tones of gray in between the two extremes. Doing this will give you some practice in seeing and differentiating value. It will also introduce you to the medium of charcoal and to the building up of a drawing surface.

Directions: On a piece of Arches paper that is at least 18 inches wide and 22 inches high, use a charcoal pencil to draw a rectangle that is 14 inches wide and 18 inches high. This will leave a border around the rectangle that is at least 2 inches wide. Cover this border with masking tape.

Next, apply a ground to the rectangle's surface. To do this put down a layer of charcoal, using the charcoal sticks. To avoid streaks and to make the ground as smooth as possible, apply the charcoal in a consistent direction (use, for example, all horizontal strokes). With a soft cloth, rub this ground into the paper's surface until it is fairly smooth. Repeat this process until the surface is a uniform middle-value gray. Don't worry about the specific shade of gray here, as long as it doesn't appear to be too obviously light or dark.

Then, using your charcoal pencil and ruler, divide this rectangle into seven vertical sections, each one 2 inches by 18 inches. Eventually you will replace these lines with an edge created by the relationship between one value and another.

Edge is the line of separation in a drawing between two shapes. When using value edge serves as the boundary between one gradation of value and another.

Make a value scale that begins with black and progresses through shades of gray to white at the end. There should be five shades of gray in between the black and white. You will have to do some correcting to get the proper progression.

Each value section should be smooth, with an even distribution of the respective value. Use the cloth, blending stomps, erasers, and your fingers to accomplish this. Especially at the edge, persist in manipulating the surface until you replace the drawn line with the appropriate value. Refer to the illustration of a value scale in this book (Figure 40) for an example of this. Notice that the edge is clear between one section of value and another. No signs remain of the preliminary lines drawn to define each section.

This exercise gives you experience in seeing value relationships and manipulating the medium of charcoal. In the following chapters you will continue working with charcoal as you learn how to use value in drawings. The skills you learned by doing the previous exercises in this book serve as the groundwork for learning the skills ahead.

Fig. 40 *Value scale*

To see is not to grasp a thing, a being, but to be grasped by it.

Frederick Franck
Zen Seeing, Zen Drawing

Chapter 8: Local Value

To begin the process of using value in charcoal drawings, you will look at the local values, or lights and darks inherent in forms. **Local values** are intrinsic to the forms and are separate from the lights and darks created by light falling on forms.

Although it is helpful to think of local value apart from the value created by the effects of light, in reality this situation does not exist. Whenever you look at form, you will always see the lights and darks created by an external light source. This external light will make the form appear lighter in some places and darker in others. For the most part, however, when you look at an egg, you will see its inherent whiteness and when you look at a crow, you will see its inherent blackness. Despite the light falling on either subject matter, in most cases the generalized local value of the egg will be lighter than the local value of the crow.

Except for black and white, the local value of colors is not always readily apparent. Sometimes when judging value, it is difficult to discern which is the darker of two colors. To make it even more complicated, the same color has different values. This means that one red may differ in value from another. It is only through the practice of looking at color relationships that you master the skill of judging value. The best way to approach interpreting value is to look closely at the color of forms and compare their value relationships, without any preconceived idea of which is darker and which is lighter. When looking, it is helpful to squint your eyes. Doing so decreases the amount of color that you see and increases your ability to judge values.

The subject matter for the drawing exercises in this chapter should accentuate the forms and shapes without a lot of lighting effects. When the effects of an external light source are discernible here, they should be minimal. When you have to take the effects of light into account, it is just a matter of looking carefully and drawing what you see.

Constructing Value Relationships from the Beginning

When you are using charcoal to create values in your drawing, the procedure is somewhat different from that in the contour drawings you did earlier. In the contour drawings, you worked on your drawing one part at a time. Even at the beginning stages of drawing, you attempted to draw every bit of the detail that you saw.

Now it is necessary for you to approach the drawing from a different point of view. You need to think of the drawing as a whole and to work on value and shape relationships from the beginning. This means that you begin the drawing by looking for large shapes and general value relationships, quickly getting down as much of this information as possible. Before you begin to go into detail, you have already

covered the entire picture plane with shapes and values and established an over-all view of the pictorial relationships that you see.

Once you have drawn the basic shapes and values, you begin to clarify and re-fine this overall view. You observe and draw the details of value that make up the subject matter. Now is the time to correct relationships by looking closely and con-sidering more carefully. For example, the overall value you have assigned to a par-ticular shape may be satisfactory, but within that shape you may see those variations of value created by external light. The more of this value detail that you get into the drawing, the more convincing your image will be.

Using Charcoal in an Effective Manner

Much of the expression and appeal of charcoal drawing comes from the way you use it. Each person will have a slightly different method of applying and manipu-lating this medium. When we look at drawings, we often respond to this "personal handwriting" more than any other element in the drawing. In learning how to use charcoal, part of what you learn is to develop your personal touch with the medium.

There are, of course, other, more technical considerations that you will learn through your exploration of charcoal. Creating a sense of light, spatial depth, and volume in your images are some examples.

As usual, close observance of the subject matter is the key to learning. How-ever, charcoal is a more complicated medium than marking pens. The way you move it around on the paper has complex and varied effects on your drawing. For this reason, it is important to discuss in detail methods of using charcoal. It is also important for you to explore your own methods. Charcoal is a tool and the way in which you use it will strongly influence the success or failure of your drawings.

Applying a Ground to Your Paper

Begin your drawing with a charcoal ground. Using a ground makes it easier be-cause you can work into this middle value from the beginning. You can draw lights and darks quickly as you erase and add charcoal to the ground. Using a ground also allows you to use the eraser easily as a drawing and blending tool.

To get a ground of charcoal, put down a layer of charcoal and blend the layer until smooth with a cloth. You should get a medium-value gray. Repeat this process until the ground is fairly smooth and of the desired value. The relative lightness or darkness of the ground may vary somewhat depending on personal preference.

Finding What Works for You with Materials

Take advantage of all the materials that you have. Review the description of their uses in the previous chapter. Experiment to find other ways of using them. There are many possibilities for using these tools. Keep in mind that the erasers are for drawing, not for removing errors. Each eraser has a different potential as a tool. To get a finer point on the eraser pencil, you can sharpen it with the pencil sharp-ener. Brushes smooth surfaces and delicately blend areas. The cloth, blending stomp, and your fingers will smooth and blend the charcoal, too.

To put it simply, you are moving charcoal around on the drawing surface. Each tool has something unique to offer in this regard. The important thing to keep in

mind is that there are an infinite number of ways to make your drawing, and these various tools offer you a range of possibilities for getting the results you want. It is up to you to try different things, to take advantage of your materials, and to find what works for you.

✦ BASIC DRAWING EXERCISE 10

Materials: Charcoal sticks and pencils, blending stomps, erasers, cloth, and Arches paper

Subject Matter: Complex still life composed of numerous patterned cloths having a variety of shapes and colors (see Figure 41).

Objectives: In this drawing, develop the local values of the shapes that you see. Look closely and get as much detail of value as possible in your drawing. Get to know the medium of charcoal by exploring the possibilities for all of the materials that you have.

Directions: Draw the picture plane with charcoal. Mask off the edges of the paper outside the picture plane. This will keep the area free of charcoal marks. Remove the tape when you finish the drawing.

Fig. 41 *Still life of patterned cloths*

Apply a ground of charcoal. To do so, cover the surface of the picture plane with a layer of charcoal. Smooth the surface with cloth and blending stomps. Repeat if necessary to get a middle-value gray.

Focus on part of the still life. Enlarge the images in your drawing. Your finished drawing will touch all four edges of the picture plane.

Begin by doing a quick contour drawing of the basic shapes of your composition. Use your eraser or charcoal to do this. Once you have the entire composition of shapes drawn, proceed by drawing the general values that you see.

As you draw these general values, look closely at the relationship of values to each other. Even at this early stage, it is important to get a full spectrum of values ranging from white to black.

Continue by looking at the complexities of values that you see in the still life and getting them down in the drawing. Use all of your tools to do this. As you work to achieve this value detail, you are refining the image and moving the drawing closer to completion.

Suggested time allowed is eight to ten hours.

✦ **BASIC DRAWING EXERCISE 11**

Materials: Charcoal sticks and pencils, blending stomps, erasers, cloth, and Arches paper

Subject Matter: Choose two or three familiar objects as subject matter. Possible choices are teapots, cups, or jars. Avoid complex, textured objects or those with transparent or highly reflective qualities because they will be too difficult to represent in terms of local value and the effects of light. The objects should be of different colors. You also need a light or middle-valued surface or piece of paper for background material (see Figure 42).

Objectives: In this drawing you are looking at the local value of the subject matter and determining value relationships within the objects. In addition you are comparing the value of each object to the others and to the background value.

Fig. 42 *Example of appropriate subject matter for demonstrating local value and value relationships*

Directions: Draw the picture plane and mask the edges with tape. Put down a ground of charcoal. Smooth the surface with cloth and blending stomps.

Arrange the objects on a plain surface of any color. Attach a piece of paper or cloth on the wall behind the objects. Do not overlap the objects when you arrange them. Instead, space them an even distance apart. Consider the arrangement carefully. It will serve as a rough sketch for the composition of your drawing. Take into consideration the negative spaces when you arrange the still life. Don't leave too much space between the positive shapes and the edges of the picture plane. Make sure that you include each object in its entirety within the picture plane (see Figure 42).

Begin the drawing with a quick contour drawing of the shapes. Next, draw the general local values for the shapes, both positive and negative. Finish the drawing by developing a full range of values that includes all of the values that you see. Remember that the more specific you are about judging value, the more perceptive your drawing will be.

In this drawing you are working on developing the relationships of values, dealing specifically with the local color of the objects and background. However, within this range of values are many variations that you will notice with close observation. By capturing these variations in your drawing, you will create a sense of volume in the objects. You will also be able to create a sense of spatial depth by making objects stand out from the background. This happens as a result of the value relationships you establish at the edges of forms. Look at the value changes in the negative spaces also. Be sure that you have a full spectrum of values, including a very "black" black and a luminous white.

Suggested time allowed is four to six hours.

✛ REFINING YOUR SKILLS

Using a Process of Putting Down Layers in the Drawing
It is helpful to think of drawing with charcoal as a process of putting down layers. The first layer is general and provides basic information that serves as the structure for what follows. In that first layer, you establish the drawing composition and a broad description of overall values.

Next, you begin to clarify the edges of shapes and to add more detail of value within shapes. Keep in mind that you are refining that first layer with the changes you make; that is, you are improving it by introducing subtleties of shape description and value changes. At this time you may also add elements to the drawing that for whatever reason you had not included before. For example, you may have only indicated the general shape of a form initially, but now you need to go into more detail by adding the particular parts of the form.

Remember that it is important to use your charcoal and your erasers as you build up the layers, moving back and forth between adding the darker values and erasing the lighter ones.

Subsequent layers make more distinctions among the different values. At every stage of the drawing, continue with close observation of the subject matter. You will probably find that the more description you get into your drawing, the more information you see in the still life. Similarly, the more descriptive your drawing becomes, the easier it is to look at the drawing and see what you need to do to improve it.

Don't feel the need to completely change every part of the underneath layer as you progress. If a part of the underneath layer is working, leave it alone.

Also, move away from your drawing from time to time. Looking at it from a distance allows you to see what needs improvement in a way that working up close does not.

Become Aware of the Surface of the Drawing

The **surface** of a drawing is the physical exterior plane of the drawing. When we look at a drawing, our first response is often to this surface. We respond to the application and blending of the charcoal. Therefore, as you build up the layers in your drawing, be aware of surface quality. One thing to consider as you build up the surface is whether the marks integrate with each other. Another factor to consider is the way areas blend together. At times marks and areas of value separate from the marks and blended areas around them. This causes discord and a lack of unity in the drawing surface. Often this happens because you are not looking closely enough at the subject matter. You need to pay attention to this and make changes when necessary.

Use all of your materials and tools when you work the surface of your drawing. Try different methods. How you move the charcoal around, make marks, and blend the areas will determine the character of the drawing surface. There are many expressive possibilities, all dependent on how you manipulate the charcoal.

Create a Full Spectrum of Values

An important consideration as you are working on this drawing is the distribution of lights and darks or the value structure. There should be a full spectrum of values, not a generalized sameness to the drawing. It is common for students to permit a middle-value gray to dominate in drawings. This happens partially because it is easy to absorb yourself in the act of drawing and to fail to see that the differences among the values in your work are minimal. One way to avoid this is to look at the subject matter and find some areas that represent both the lightest and the darkest values. Draw the values for these areas at the beginning of your drawing. You have then put in the extreme darks and lights and established a basis for determining other value relationships.

Fig. 43 *Value shifts at edges of forms create a volumetric quality and a sense of spatial depth.*

Define Edges of Shapes with Care

For our purposes it is important to define the edges of shapes carefully. Doing so enables you to describe the volume of forms and the appearance of spatial depth more easily. In Figure 43 the edges of shapes are carefully articulated, giving the drawing a rich sense of clarity and completeness that wouldn't exist otherwise.

When refining the edges of shapes in drawings, you must make sure the value shift between the positive shape and the negative spaces is distinct enough to create a definite edge and accurate enough to create the desired three-dimensional effect. Look closely and compare values, possibly even exaggerating the difference between them. Notice that in Figure 43 the careful description of value shifts at the edges of forms gives the objects a quality of volume and also creates a sense of spatial depth between them and the surrounding space. This drawing is also a good example of close observation of value changes along edges. The shapes are not outlined by a consistent line encompassing their edges, but instead reveal a number of shifts in value along their contours. This quality further evokes a sense of volume and form; without it the shapes would flatten out and appear much more two-dimensional in character.

Fig. 44 *Tonal variation and surface manipulation create an integrated surface and a sense of spatial depth.*

Be aware of the negative spaces and treat them as carefully as you do the positive ones. Even if there is relatively little information in the negative spaces, they still play an important role in the development of your drawing. As you can see in Figure 44, the variation of tone and subtle manipulation of surface in the background area interacts with the shapes of the objects to create an integrated surface and a sense of spatial depth in the drawing.

The manner in which you define edges describes the physical characteristics of the subject matter and determines the expressive qualities of your drawing. This means that there are many ways to finish the edges of shapes in your drawing. Sometimes the subject matter requires that you draw edges to be sharp and distinct. Other times you would draw them to be soft and blurred, or any number of other ways. The important thing is to be aware of and in control of decisions you make when drawing edges.

Fig. 45 *Softened blending at edges reflects the softness of the subject matter.*

Consider the physical appearance of the objects and shapes when you are drawing. In the drawing of Figure 45, the softened blending at edges of patterns and folds conveys a quality of light and form that describes the softness of the cloth. In comparison, the edges of shapes in Figure 41 are sharper and more distinct. This difference in handling of edges creates a subtle difference in the qualities of light and form in the drawings and in our impression of the subject matter.

❖ SKETCHBOOK ASSIGNMENT

Materials: Charcoal, sketchbook

Directions: Do a drawing every day. Date each drawing.

Do drawings in your sketchbook of natural or manufactured objects. Use value when you do these sketches. In these drawings, the lightest value will be the white of your paper. These are to be quick sketches; don't spend a lot of time on any one of them.

♣ DRAWING CRITIQUE

What Are the Objectives?

In these drawings you began using value. In particular, you looked at local value or the value inherent in the forms of the still life. In order to do this, you had to translate the color you saw into value by making comparisons and judging the degree of lightness or darkness of one form in relation to another.

Some changes of value are due to sources of external light. When you describe these shifts, the objects will become more three-dimensional and a sense of spatial depth will become apparent. As you can see in Figure 43 and Figure 44, this effect of an external light shining on the objects is apparent. Primarily though, these drawings are not about depicting the effects of external light on subject matter as much as they are about the variations of value within the color of objects.

When using value, another objective is to construct a full spectrum of values, making sure to include the extremes of light and dark.

In addition to seeing and drawing values, you also learn to use the medium of charcoal and the various other tools that accompany it. Through this manipulation of charcoal you become aware of the drawing surface and its importance to the success of your drawing. Part of the successful development of a drawing surface includes unifying and blending marks and values into each other.

As you learn to distinguish between edges of shapes and outlines, you also learn to be attentive to the definition of edges, carefully defining them through the juxtaposition of one value and another.

How Do You Determine if the Objectives Have Been Accomplished?
When looking at these drawings, the first thing to note is the use of value. There should be a wide range of values, including black and white. There should also be enough variation of value to indicate that there are definite distinctions between one color and another in terms of value.

Drawings should have well-developed surfaces. It should appear that elements such as the edges between shapes, blending of values, and marks on the drawing surface have been carefully resolved. When looking at the drawing in Figure 46, you get a sense of a style emerging from

Fig. 46 *Skillful rendering of surface of forms conveys the sense of an individual style emerging.*

surface appearance. No part of the surface seems discordant with the rest or unfinished in any way. There is a skillful rendering of surface of form that shows the individual's touch and remains consistent throughout the drawing.

To some extent, there should be an illusion of volume in the objects and a sense of spatial depth. Variations of value within forms and between edges of shapes create this effect. Edges of forms should be convincing in that they reinforce the sense of volume and create a subtle effect of spatial depth. In no case should the shapes appear with contour outlines.

Questions to Ask Yourself When Discussing Drawings for Exercise 10 and Exercise 11

1. Do you see a fully developed value structure in the drawing? If not, where do you think it is lacking? Is the value differentiation carefully observed? What about the drawing indicates this is true?
2. Are the edges of shapes clear and well-defined? How does the definition of edges affect the illusionistic qualities of the image? Are there any areas where the drawing flattens out spatially because of the way edges are drawn?
3. What part of the drawing reveals skill in the handling of the medium of charcoal? What specifically has been done to indicate this? Are there areas where this could be improved?
4. How would you describe the surface of this drawing? Is there anything in particular that you find visually appealing, and why?

A pepper is not a vegetable that is good in salads. It is a remarkably complex, undulating green surface vaguely suggestive of the human form. This is part of what is meant when people say that artists see "differently."

Anna Held Audette
The Blank Canvas: Inviting the Muse

Chapter 9: Value and Form

In the previous chapter you learned about local value and seeing the range and complexity of value relationships. You also learned the importance of establishing the relationships of values at edges between shapes and the role of value in creating the effect of volume and spatial depth. As you continue to develop your skills with charcoal, you will benefit from looking at value as it creates a sense of three-dimensional form. Every object has its specific three-dimensional character, and we recognize this quality when we observe the play of lights and shadows on form. Shifts from one value to another occur in different patterns, depending on the surface of the forms. Angular forms result in abrupt shifts in value, while curved forms show more subtle gradations of value.

When creating a sense of form or three-dimensionality in drawing, you must look closely to see the complex shifts in amounts of light or dark. You must also notice how the value gradations occur. For example, value changes on the surfaces of a cardboard box will be quite different from those on the surface of a ceramic cup. The drawing of radishes (Figure 47) describes the surface and form of these objects quite well because of the ranges of values used, relationships of values at edges of forms, and subtle blending of values within the forms.

Building of Complex Value Relationships

As before, you begin building values in a generalized way by quickly drawing in major shapes and their basic value. In this way, you will immediately establish overall value relationships. Because we see value through relationships, it is only by setting up a scale for comparison first that we can continue to develop the more complex value gradations that follow. It is also important to make sure that you have the darkest areas of value as well as the lightest established from the beginning. Doing so will ensure that the drawing has a full spectrum of values and is not too much in the gray range.

Once you have the basic values drawn in, continue by developing more fully the value range. You do this by looking closely and putting down the many gradations of value that you see. The more carefully you look at the subject matter, the more value differentiations you will notice. Likewise, the more value changes you get into your drawing, the more complex and sensitive your drawing will become. Even with the relatively simple subject matter of Figure 48 (eggs), the range of

Fig. 47 *Close observation of gradations of value creates a convincing sense of surface and form.*

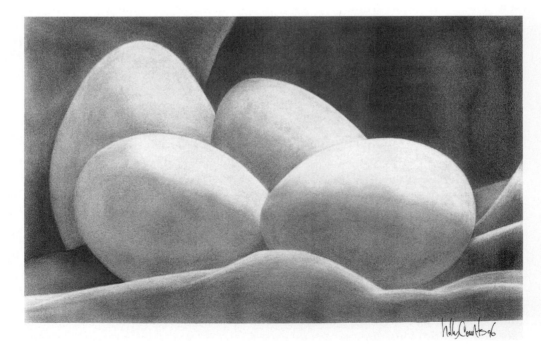

Fig. 48 *Range of values used to depict light and form in a drawing of eggs*

values used is complex, thus creating a convincing depiction of light and form in this drawing.

Creation of Volume with Value

Every form has a three-dimensional quality that we define as volume. This volume gives us a feeling for the height, width, and depth of objects. Through the depiction of volume or three-dimensional form, artists convey a sense that the subject exists in a tangible space, even though it is simply a representation of space on a two-dimensional surface.

Changes of value on the form's surface make us aware of that form's volume. In Figure 49, the parts of the forms that are closer to a light source are illuminated. In comparison, the parts of the forms that are hidden from the light and in shadow are darker. Our visual perception tells us that this presence or absence of light indicates particular aspects of the form's volume. Through our perception of light, we see and understand the volume of these forms.

To describe the volume of forms in drawing, it is necessary to observe and draw the variations of light and dark as they describe the surface of forms. These lights and darks are created by an external source of light and exist along with the local value of the form's colors.

Value Shifts at the Edges of Forms

As you observe the surfaces of forms and describe the effects of light on these surfaces in your drawings, you must continue to be aware of value shifts at the edges

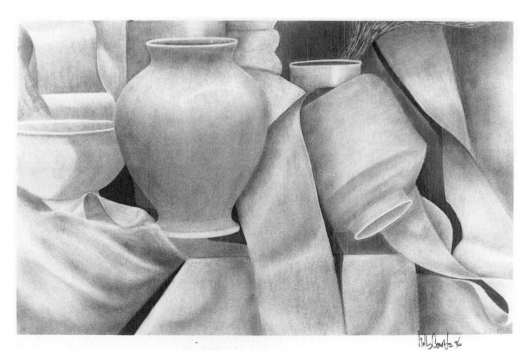

Fig. 49 *Depiction of light-illuminated forms creates a sense of volume.*

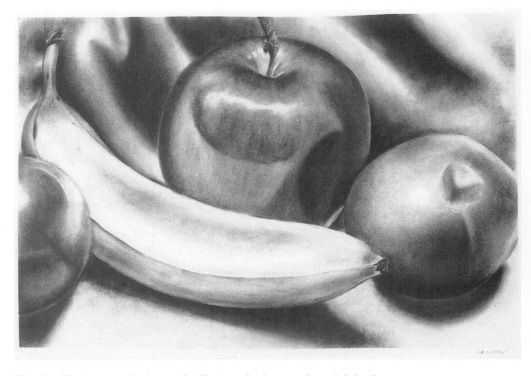

Fig. 50 *The impact of value on the illusion of volume and spatial depth*

between shapes. Notice in Figure 50 how the description of value has a strong impact on the description of volume and spatial depth in the drawing. The value relationships between objects and the surrounding spaces change frequently throughout the drawing. The edge of the apple on the right is darker than the background in some places and lighter in others. This sensitivity to shifts of value helps to create a sense of volume in the forms and heightens the illusion of spatial depth in the drawing. The higher the contrast at these edges, the more depth in space occurs. Conversely, the less contrast between values at edges, the less depth in space results.

Value Shifts on the Surface of Forms

As you develop the values within forms, you should pay close attention to the way that values blend into each other on the form's surface. The edges between value shifts determine to a large extent the surface quality of the forms. We get a sense of the texture of the surfaces of objects through our perception of these value shifts. For example, in Figure 51 the values move gradually from light to dark in the cloth of the background area, thus giving us a sense of the soft surface of that fabric. In comparison the value changes are more abrupt in the celery and as a result create the illusion of ridges on the surface of these forms. In many ways our visual perception gives us clues with which to interpret images. In other words, the perceptual abilities we use to understand the physical world, we also use to aid our understanding of drawn images.

 Once you observe the character of edges between shapes of values in objects, you must then determine how to depict these qualities. How you blend areas of the charcoal surface will determine this. Try different tools to get the effects you want. Obviously you would blend the surface differently when depicting the soft

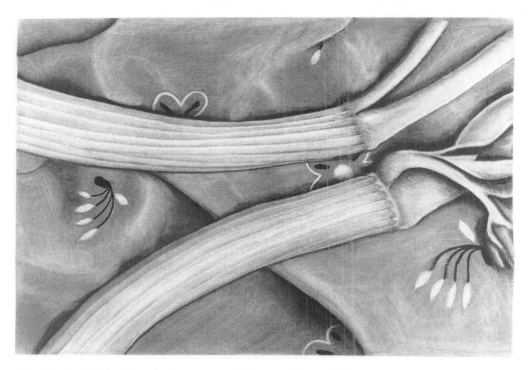

Fig. 51 *Varied blending of values creates different surface qualities.*

cloth than you would when depicting the ridges of the celery. You cannot use the
same methods to convey transitions in one as you do to convey transitions in the
other.

✦ BASIC DRAWING EXERCISE 12

Materials: Charcoal sticks and pencils, blending stomps, erasers,
cloth, and Arches paper

Subject Matter: Complex still life composed of various forms with an
obvious three-dimensional quality. Examples of such forms would be bot-
tles, vases, cups, boxes, bones, and gourds. The list is endless. Combine
these objects with pieces of fabric that fold and drape in the still life.
Shine a directed light on the still life to heighten the contrast between
light and dark.

Objective: In this drawing, the goal is to create a sense of three-
dimensional form and spatial depth through depiction of values that are
created by an external light source.

Directions: Draw the picture plane with charcoal. Mask off the
edges of the paper outside the picture plane. Apply a ground of charcoal.

Find a position that gives you an interesting view of the still life. Focus in on the part of the still life that you choose to draw. The finished drawing will fill up the entire picture plane. Some objects may extend off the edge of the picture plane or all of them may be contained within it.

Begin with a quick contour drawing and put in the basic shapes without detail. Next, add the basic local values that you see.

Proceed by building up the details of value, form, and surface. Look closely at changes in value, paying attention to the effects of light on the surface of forms. If there are cast shadows, look closely at the values here also. Treat the shadows as if they are shapes and look at them in the same way that you look at the objects.

Get a wide range of values. Work on the drawing until you are confident that it is complete.

✦ BASIC DRAWING EXERCISE 13

Materials: Charcoal sticks and pencils, blending stomps, erasers, cloth, and Arches paper

Subject Matter: Choose two or three familiar objects with simple forms. Choose objects based on shapes and colors, not on their identity. Select a plain background material of fabric or paper.

Objective: In this drawing the objective is to create a sense of volume, form, and spatial depth through observing gradations of value and the effects of light.

Directions: Draw the picture plane with charcoal. Mask the edges. Put down a ground of charcoal.

Arrange the objects on a plain piece of paper or fabric. Tack a plain piece of paper or fabric on the wall behind the objects. When arranging them, consider how you place them. They can overlap each other or not. Look at negative spaces to see that they work well with the forms.

Shine a light on the objects so that you have parts of them illuminated and parts in darkness. Also arrange the light so that it creates cast shadows.

Do a drawing of the still life using a full range of values. Look closely at the forms and negative spaces to get in as many gradations of value as

you can see. Pay close attention to edges between forms and spaces, observing the complexities of value here also. Try to create a sense of volume and spatial depth in the drawing through the articulation of values.

Develop the surface of the drawing as fully as possible by constantly evaluating the drawing in terms of manipulation and blending of values.

✦ BASIC DRAWING EXERCISE 14

Materials: Charcoal sticks and pencils, blending stomps, erasers, cloth, and Arches paper

Subject Matter: Three or four eggs arranged on a piece of white fabric.

Objective: The goal in this assignment is to create a sense of volume and spatial depth in the drawing through close observation of values and the effects of external light. The subject matter in this case is subtle in color and texture. Another goal is to describe this subtlety of color and texture with fine distinctions of value differentiation and blending of charcoal (see Figure 52).

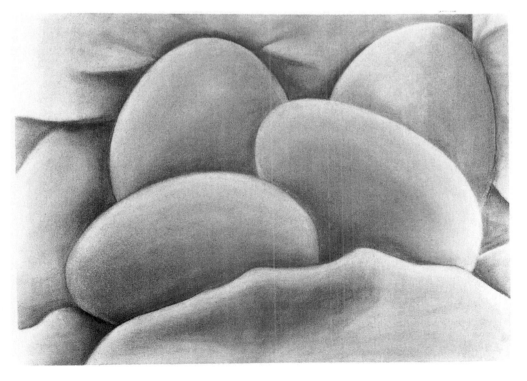

Fig. 52 *Value differentiation used to describe the subtlety of color and texture in eggs*

Directions: Draw the picture plane and mask the edges of the paper. Put down a ground of charcoal.

Place the white cloth or paper on a table top or other flat surface. Tack part of the paper or cloth on a wall behind the table. Arrange the eggs on the cloth or paper, considering composition as you do so. You may overlap them or not; this is a matter of personal choice. However, in either case look at the negative spaces as well as the positive shapes when determining whether the arrangement works.

Shine a light directly on the still life so that it creates cast shadows. Draw the complexity of values that you see, including black. Look closely at value differentiation within the eggs. Blend the values carefully so that the forms have a smoothness and roundness to them. Observe closely the subtle value changes within the lights and darks of the eggs. Also look closely at the cast shadows and the value shifts within them.

✛ REFINING YOUR SKILLS

Use Charcoal in a Personal Way

In this chapter, you still begin your drawings with a ground. It is, of course, acceptable, perhaps even desirable, to begin drawing right on the paper's surface, but for our purposes, it is helpful to continue working into a ground. Doing so speeds up the development of the drawing's surface and enables you to use both the charcoal and the eraser when drawing.

Continue to experiment with moving the charcoal around and blending values into each other. There are many ways to use the medium. How you choose to do so is determined in large part by personal preference, so make choices based on what you think looks best. Keep in mind that this varies from person to person. Part of finding your own style in using this medium depends on your ability to make these personal choices. The drawing style in Figure 53 creates a softened effect of diffused light throughout the drawing. The underneath layer of ground shows through in areas and adds to the heightened effect of light. In contrast, use of the charcoal medium in Figure 54 emphasizes the solidity of forms and the effect of light on the surface of these forms. The student uses a different approach by building up the ground and blending the charcoal to describe the surfaces of these forms.

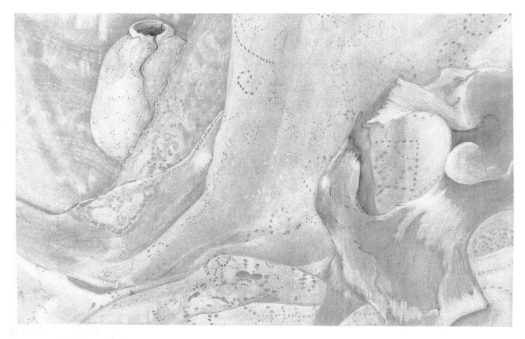

Fig. 53 *The softened effect of diffused light on cloth reveals one artist's personal style.*

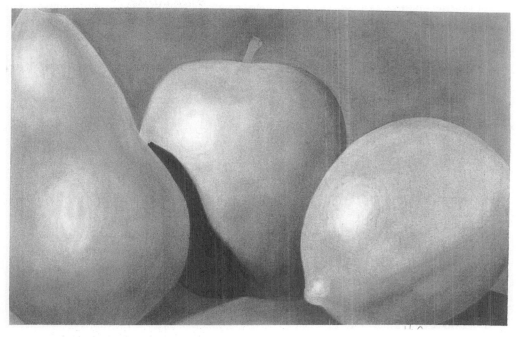

Fig. 54 *Charcoal emphasizes solidity of forms and the effect of light on surfaces.*

This method of drawing is a process of putting down layers. Your drawing becomes more detailed and finished as you progress. The surface also becomes more resolved. You must allow the drawing to go through all of the necessary layers or stages of development. Don't make the mistake of calling it finished before that time has come. Often the most effective changes come at the last moments of a drawing's development.

Be Aware of the Drawing Surface

Continue to develop your sensitivity to the drawing surface. Many of the expressive qualities of a drawing come across because of this element. Although it is a difficult element to describe, the beauty of a drawing surface is easily recognized when it is there.

Among other things, when developing the surface, pay attention to the integration of surface marks, the nature of value contrasts, and the articulation of edges.

Develop Balance in the Composition

In previous drawings, when you considered composition you looked at the relationship of forms to each other and to the negative spaces. You used an intuitive approach to thinking about composition. You should continue to use these tools to develop compositions for your drawings.

Composition is the pictorial design of your drawing. Good composition does its job so well that you hardly notice it. Composition is the relationship of all lines, shapes, and other elements of the drawing to the four edges of the picture plane and to each other. In all of the drawings you have done in conjunction with this book, the first four lines you make are those edges of the picture plane.

When you look at the shapes and negative spaces in your drawing, you see them in relation to the edges of the picture plane. When you fill up the picture plane with images and either touch the edges or nearly do so, you automatically ensure that you have covered the entire surface of the picture plane with compositional elements. However, this is not enough to guarantee a satisfactory composition. You must continue to be aware of the negative spaces between objects. Use your intuitive judgment of what is pleasing to determine if the negative spaces are working well with the positive objects. If you make the negative spaces between shapes too large or too small, this can throw the composition off-balance.

Balance is one of the most important elements in good composition. When the shapes, lines, values, and other drawing elements work well together, you should be able to discern some sense of visual balance. One part of the image must not outweigh other parts. You can determine whether this balance exists by noticing how your eye moves throughout the image and if it rests in one place noticeably longer than in others. In Figure 55 you can see an example of visual balance. Here every part of the picture plane is activated by the shapes, both positive and negative. The eye travels back and forth, across, and up and down the drawing. The negative spaces provide an effective visual counterpart to the positive ones and thus strengthen the balance of the composition.

Of course, there are several other important qualities to look for and think about in terms of composition. Because a more thorough discussion of composition is not desirable for our purposes, it is sufficient for you to remain aware of the negative spaces and the edges of the picture plane. Continue to use your intuitive judgment when determining if your composition is working .

One final note about composition: Your point of view on the subject matter is extremely important. It may seem that it is not important where

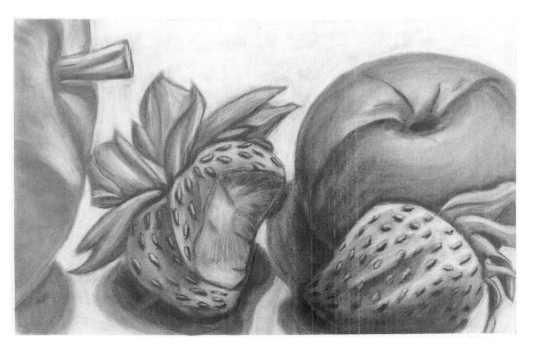

Fig. 55 *Use of positive and negative spaces or shapes to create visual balance*

you stand in relation to the still life or where your eyes are in relation to your subject matter. On the contrary, these are extremely important factors. Where you are in relation to your subject matter determines to some extent the success or failure of your composition. By moving the position of your head slightly one way or the other, you can change the composition entirely. Often it is tempting to take the usual position, whether it be in the classroom or at home. But what happens as a result can be a boring and obvious viewpoint. Remember to move around and try different positions to prevent this from happening.

Observe the Complexities in Light and Shadow

We have seen that it is necessary when defining value to look closely and get down as many of the variations of value as you can see. Doing so allows you to create a sense of volume, surface, and spatial depth in your drawings.

There are some particular aspects of light that would be helpful to know when looking at the subject matter. Light and shadow are the broad, general areas of value in your drawing. In the beginning stages of the drawing, establish these general values. As you continue the drawing and work to refine it, put in the more defined areas of light such as the highlights and the core of shadows. You will notice that areas of shadow on forms have much variety in them. The same is true of cast shadows. Light reflects back onto the form and into the shadow to result in this variation. Look closely at shadow areas and try to describe all of the values you see in your drawing. The more variation you incorporate in your drawing, the more sensitive the drawing will be in its depiction of the subject matter.

❖ **SKETCHBOOK ASSIGNMENT**

Materials: Charcoal and sketchbook

Directions: Do a drawing every day. Date each drawing.

Look around and find spontaneous still lifes. These are still lifes that you use just as you find them, without any arranging on your part. Do a quick study of these still lifes, using charcoal and value to define form and spatial depth.

♣ DRAWING CRITIQUE

What Are the Objectives?

In these drawings, as in the previous ones, you described the local value of forms. In addition to this, you drew the value created by an external light source. By drawing the illuminations and shadows of the subject matter, you were able to create a three-dimensional effect in the image as well as a sense of spatial depth.

It is important to get a full range of values in the drawing, including black and white. There should also be many gradations of value that reveal the characteristics of your subject matter. These characteristics include a sense of the volume of forms, spatial relationship of forms to each other and to the surrounding space, and the textural qualities of the forms' surfaces.

The effects of external light on the surfaces of objects and on the surrounding space should be evident in the drawings. The viewer should be keenly aware of an external light.

In the drawing edges should be clearly defined. Marks need to integrate with each other, and values should effectively blend with each other.

In these drawings composition is also an important element. There should be a satisfactory structure in the drawings, with the picture plane activated by shapes, lines, and marks. There should be a sense of visual balance to the composition.

How Do You Determine if the Objectives Have Been Accomplished?

When looking at these drawings, the first thing to notice is the use of value. Look for a wide range of values, including black and white. Enough variation of value should be evident to indicate the volume of forms and the movement of forms in space. The distribution of value and the blending of value areas together should create a sense of the volume and surface of forms. None of the information in a drawing should contradict our perception of the forms. Similarly, we should get a sense of the textural quality of forms through the use of value and the manipulation of the charcoal medium.

The drawing surface should have a finished quality to it. If it appears to need further development either through refinement of values, blending of values, or any other means, then the surface is not fully developed.

All parts of the drawing surface should integrate, with no area separating from the whole.

The composition of the drawing should appear to be complete, with a sense of unity and balance. If any part of the drawing seems to lack visual interest, then it may be due to compositional problems. If one part of the drawing seems to dominate another, then the composition is off-balance.

**Questions to Ask Yourself When Discussing Drawings
for Exercise 12, Exercise 13, and Exercise 14**

1. Are the values fully developed? Are there any places in the drawing where the use of value contradicts your understanding of the forms depicted? Do you get a sense that objects have clear spatial relationships within the still life? Are surface textures believable to you?
2. Are edges of forms in drawings articulated clearly? What effect do the edges have on the overall drawing? Do the edges of forms reinforce their structure or deny it?
3. Does the surface of the drawing indicate an understanding of how to use the medium of charcoal? Is there a personal style evolving in the drawing? Are surface marks fully integrated with other areas of the drawing?
4. Are you satisfied with the composition of drawing? How do you know it is successful?

Learning to draw is really a matter of learning to see—to see correctly—and that means a good deal more than merely looking with the eye. The sort of "seeing" I mean is an observation that utilizes as many of the five senses as can reach through the eye at one time.

Kimon Nicolaides
The Natural Way to Draw

Chapter 10: Sighting Perspective

Thus far in your work with value you have learned to draw local value and to describe the effects of light on form. Both of these skills help you to create a sense of volume and spatial depth in your drawings. We will now add another important drawing skill to your list of accomplishments. It will be that of drawing perspective. **Perspective** is the representation of things on a flat surface as they are arranged in space and as they are seen from a single point of view. Knowing how to create perspective is extremely important in drawing, because it gives you control over the illusionistic qualities of your drawing.

Creating Perspective Through Observation

There are two methods for creating perspective in drawing: linear perspective and sighting perspective. **Linear perspective** is a logical system of rules for creating the illusion of three-dimensional space on a two-dimensional surface. **Sighting perspective** is a method for drawing perspective that relies on what the artist observes rather than on a set of rules. Because sighting perspective relies on your powers of observation, it will be the method we use in this book. The skills you have developed thus far in regard to looking and translating what you see in terms of drawing are what you need here to develop your skills in perspective.

To use sighting perspective you must look closely and draw what you see, not what you *think* you see. This approach is not new for you; it is the method you have used for all of the exercises in this book so far. Nevertheless, despite all that you have learned, you may find that the nagging voice of logic tries to convince you otherwise. You may find that your ideas of what is right or logical in regard to putting things in accurate perspective may contradict what you are actually seeing. Thus, you may find it necessary to set your analytical judgments aside and rely on your skills of observation as you determine how to create a convincing sense of perspective in your drawings.

The Importance of a Fixed Point of View

A **fixed point of view** is the consistent position of the viewer's eyes in relation to the subject matter. When you are drawing perspective you have to maintain the same bodily position while you are observing the subject. You can't move closer, to the left or right, or even tilt your head differently. Otherwise your view of the subject will change and your drawing will reflect this inconsistency. See if you can tell in looking at the drawing in Figure 56 where the student artist stood in relation to the corner of the room depicted. Figuratively speaking, we are seeing through his eyes. Every line and angle in the drawing reinforces the consistency of this point of view.

As you are drawing, you need to be aware of your position. If you move, it will become apparent, because the angles and lines in the drawing will look wrong.

Making and Using a Viewfinder

A viewfinder is a framed opening through which you can see a selected part of the visual information in front of you. You most likely have used the viewfinder on a camera to frame your subject before taking a photograph.

Fig. 56 *Line and angle used to reinforce the consistency of the point of view in the corner of a room where walls meet ceiling.*

For the drawing exercises in this chapter, a viewfinder is essential. It will help you to maintain a consistent point of view on the subject and to measure lines and angles that you see. Both of these tasks are necessary when drawing things in perspective.

Construct a viewfinder as follows:

1. Use a sheet of paper or thin cardboard that is the same size as your drawing paper. Thin cardboard works best because it remains rigid when you hold it up for viewing. The paper for your drawing and your viewfinder need to be the same size so that they will have the same format. **Format** is the overall shape and size of the drawing surface.

2. On the viewfinder, draw diagonal lines connecting opposite corners. These diagonal lines will cross in the center. Next, draw a small rectangle in the center of the viewfinder. The four corners at which the horizontal and vertical lines of the rectangles meet should lie at points on the diagonal lines. This small rectangle in the center of your viewfinder should measure approximately 2" x 2 1/2". Size can vary depending on your subject matter and personal preference.

3. Cut the small rectangle out of the center. Hold up the viewfinder and compare the shape of this rectangle with that of the outer edges of the paper and with the shape of your drawing paper. All three rectangles should have the same shape even though they are different sizes.

At this point you may want to cut down the outer edges of the viewfinder to make it easier to hold up and look through.

To use this viewfinder, hold it up and close one eye when looking through it. Every time you look at the subject matter, the viewfinder should be the same distance from your eyes. To maintain a consistent distance, make note of how far you are holding it from your face, or if possible, always hold it at arm's length.

Choosing a Vertical Line to Use as a Reference Point

Seeing and measuring visual relationships is a key factor in everything you have done so far in this book. When learning to use sighting perspective, it is essential that you observe and draw visual relationships carefully. The most important word here is *relationships*. You are considering every part of the drawing as it relates to every other part. Specifically, you are measuring all of the lines, angles, and shapes that you see in relation to each other.

In order to do this measuring, you must first establish a reference point in your subject matter. This reference point will serve as a basis for measuring all of the other lines and angles that you see.

For the basic drawing exercises in this chapter, the reference point that you use will be a vertical line that you find in the subject matter. It can be the corner of a room, the leg of a table, or any other vertical line that you choose. (For our purposes we are using a vertical line. However, in other instances, a horizontal line will work as well.)

As you are drawing, use this line to align your position in relation to the subject matter. When you move away from your original position in relation to the subject, you can return to the same position by using this vertical line as a gauge.

You will also measure all other angles and lines in your subject matter in comparison to the chosen vertical line. Regardless of how far removed you get from this line, you can always trace your vision back to this starting point. This may

sound a bit confusing to read, but when you begin drawing, it should become obvious how to use this visual measuring device.

You must also be aware that this vertical line corresponds to the vertical edge of your viewfinder and the vertical edge of your drawing paper. Once you have chosen this component in your subject matter, you must keep it in a consistent position in your viewfinder and subsequently in your drawing. We will discuss this concept in more detail later, while you are doing the basic drawing exercises.

Value as It Relates to Cast Shadows

In these drawings, use value as you have in previous drawings by depicting the local value and form of the elements in your subject matter. In addition to this, you will also look at shadows in the subject matter.

When drawing shadows, you must take note of the shape of the shadows by measuring them carefully and drawing them as you would any other shape. You must also look closely at the values of shadows. By sensitively observing and drawing these areas of the subject matter you will heighten the sense of light as well as spatial depth in your drawing.

The effects of light on the subject matter, in the form of shadows, serve as a complementary element to perspective. By using both simultaneously, you will have even more control over the form and space you create in drawing. As you can see in Figure 57, the depiction of shadows works synergistically with the depiction of perspective to convey a dramatic sense of the light and spatial depth in

Fig. 57 *Together, shadow and perspective convey light and spatial depth.*

the still-life objects. The shadows are drawn in perspective and also have varying gradations of value. Both of these factors contribute to the illusionistic powers of this drawing.

Method for Beginning the Basic Drawing Exercises

The instructions for beginning the basic drawing exercises in this chapter are more elaborate than those of previous chapters. For this reason they precede the exercises. Read them carefully before you begin the drawings and reread them as necessary while you are working.

Begin by drawing the vertical line that will serve as your reference point. This vertical line is parallel to the edge of your viewfinder and, when drawn, should be parallel to the edge of your picture plane. Continue to work by drawing the lines of other shapes as they meet up with this vertical line. When you draw these lines, duplicate the angles at which they intersect the vertical line. Also check to make sure that these lines intersect with the picture plane in your drawing at the same relative place as they intersect with the edge of the viewfinder.

Continue to draw all of the other angles, lines, shapes, and spaces that you see in your viewfinder, stepping back periodically from your drawing to check for accuracy. Usually we know when the perspective is not right because our perception tells us something is inaccurate.

As you work, measure lines in relation to each other, making sure that the lengths are in the correct proportion to each other. **Proportion** is the relative size of part to part or part to whole within a composition or object.

◆ **BASIC DRAWING EXERCISE 15**

Materials: Viewfinder, charcoal, Arches drawing paper

Subject Matter: Interior space having a vertical line to use as a con-
stant, preferably the corner of a room. Shine a light on the interior so that
you have a number of cast shadows.

Objectives: There are two objectives in this assignment: (1) to
create a sense of perspective through the use of sighting and with the aid
of a viewfinder and (2) to create a sense of spatial depth through the use
of values and the depiction of cast shadows.

Directions: Apply a ground to the drawing paper. Using your
viewfinder to guide you, locate a part of the room that you will draw.
Make sure that there is at least one vertical line that you can use as a con-
sistent reference point in your drawing.

Begin by drawing the basic lines, angles, shapes, and spaces of your
composition. Compare and measure degrees of angles and lengths of

lines carefully. Reread the instructions earlier in this chapter that describe in detail a method for doing this.

Once you are satisfied with the lines and angles of perspective, begin adding value to the drawing. Proceed as you normally would to do this. Look closely at values. Begin with the basic ones. Add more subtleties of value as you proceed. In addition, draw the cast shadows that you see. Look closely at the shapes and variations of value within these shadow areas.

Suggested time allowed is four to six hours.

◆ **BASIC DRAWING EXERCISE 16**

Materials: Viewfinder, charcoal, Arches drawing paper

Subject Matter: Still life composed of simple, geometric forms such as boxes or paper bags, along with simple curvilinear forms. A directed light shines on the still life and creates a number of cast shadows, as well as abrupt changes in value. A white wall, paper, or cloth is used as background for the still life.

Objective: In this drawing, the objective is to create a sense of volume, form, and spatial depth by using perspective and by drawing the effects of a directed light on the subject matter.

Directions: Apply a ground to the paper, making sure that the drawing surface is the same format as the viewfinder you will be using.

Arrange the forms in this still life so that they receive light from above. You should be able to see the angular edges dividing planes within the objects.

Using your viewfinder, focus in on the objects and position them within the picture plane. Find the vertical line that you will use as a reference point. In this drawing you should have a **closed composition** in which all of the forms are contained within the edges of the picture plane.

Begin by making a line drawing of the composition. Compare and measure lines, angles, shapes, and spaces carefully. Apply the methods described earlier to do this.

When you are satisfied with the sketch in regard to composition and perspective, continue by drawing in or erasing the general dark and light

values that you see. Observe the objects and their cast shadows carefully. Build up gradations of value that correspond to the separate planes of the objects and to the cast shadows that you see. Keep working until you have developed the drawing fully.

Suggested time allowed is four to six hours.

✛ REFINING YOUR SKILLS

Understanding the Concept of a Fixed Point of View

When looking at accurate perspective drawings we instinctively understand the implied point of view. We can identify whether the artist was looking up at, down on, or straight ahead at the subject matter. It is easy to see that in Figure 58 the student was looking up at the ceiling as he drew. He did an admirable job of convincing us of this through his measuring of lines and angles as they intersected with the vertical edges of the doorway. In order to use sighting perspective effectively, he had to

Fig. 58 *Use of sighting perspectives to depict corner of ceiling*

maintain the same position in relation to the subject throughout the drawing. His fixed viewpoint on the interior setting provided us with a convincing illusion of space.

To understand fixed position, you need to understand the concept of eye level. **Eye level** is the height at which your eyes are located in relation to the ground plane. Eye level is defined when you are looking straight ahead, and it falls at the point on the wall directly in front of you. If you are outside, eye level is a point on the horizon line of the landscape. Perceptually we understand this concept of eye level, so much so that we take it for granted. However, in order to maintain a consistent point of view in your drawing, you need to be conscious of where the chosen point of view exists in relation to your eye level. If you begin the drawing by looking up at the subject matter or looking above eye level (Figure 57 and Figure 58), then you need to continue to focus on the subject in this way throughout the drawing. By doing so, you are always assured of measuring lines and angles in relation to the same viewpoint.

Vertical Constant and the Skill of Making Comparisons

In learning about sighting perspective you are developing further the skill of making comparisons in your drawings. Once you have established the first vertical line in your drawing, then every other line and angle you draw you must compare to this line. In many ways the ability to make these comparisons lies at the core of successfully drawing from observation.

The vertical constant in your subject matter is repeated in your drawing. Every angle and line you see through your viewfinder relates to this vertical constant and subsequently to the vertical line in your drawing. Think of this line as your anchor. As long as you are visually connected to it you will be able to measure and draw accurately any other lines and angles in the subject matter, regardless of how complicated they may be.

Using the Edges of Your Paper

In all of the previous exercises in this book you have drawn the picture plane before beginning the drawing. Doing this made you more aware of the edges of your drawing surface. This awareness helped you to develop the composition of your drawings successfully. Now there is another reason why awareness of the edges of the paper or picture plane is a useful tool. They are horizontal and vertical reference points in your drawing. When you draw vertical and horizontal lines you can measure them in

relation to these edges. This means that you have several reference points to use when measuring lines, shapes, angles, and spaces As you continue to establish relationships and the complexity of comparisons increases in a drawing, you can simplify the task of measuring by using these edges as visual guides. In Figure 59, an interior, a large number of lines, angles, and shapes must be drawn in relation to each other. This student artist used the vertical edge of the window as a beginning reference point, but

Fig. 59 *Vertical and horizontal edges serve as visual guides in measuring the lines, angles, shapes, and spaces that create perspective.*

as the drawing progressed, she also used the horizontal and vertical edges of her viewfinder and her drawing paper to guide her in measuring lines, angles, shapes, and spaces.

Using Value in Shadow Areas

Once you have established the composition of your drawing and have a fairly accurate representation of perspective, you need to begin applying value to the image. As usual, begin by constructing the basic value structure of shapes, including those of the cast shadows. As you continue to work on detail of value, pay close attention in particular to the value of shadows.

Shadow areas are complex and need to be carefully observed in order to describe this complexity. To begin with, you must draw the shapes of shadows accurately. You will use perspective in these areas, too. The articulation of shadows in Figure 60 convincingly supports the drawing of

Fig. 60 *Value shifts in shadow areas create an immense amount of light.*

perspective in the dollhouse. The shape of the shadow on the wall reflects the shape of the dollhouse with just enough distortion for us to read the distance between the lamp and the shadow easily. This success is due in large part to the carefully observed drawing of shadow areas.

Another aspect of complexity in shadows comes from the variation of value within them. It may be tempting to make shadows one value and simplify them, but this will defeat the purpose of creating an illusion of light and spatial depth in drawing. By looking carefully at the shadow areas and observing the changes in value, you will have more power over the space and light in your drawing. Again in Figure 60, we can see an immense amount of light in this drawing due to the student's sensitive handling of value shifts within the shadow areas. She has made us aware of the light coming from the lantern and its impact on the rest of the still life. Her use of value in this drawing supports and strengthens her use of perspective.

Using Value to Define the Form of Shapes

In this chapter's exercises you will use value to define the planes in forms. The subject matter is illuminated by a direct light source. As a result of this there are a number of cast shadows in the still life or interior setting. Where the forms exhibit abrupt changes in the directions of planes, as in the case of geometric objects or architectural settings, there will be an abrupt change in the amount of light hitting these planes. By articulating these value shifts in your drawing you can accentuate the three-dimensional forms of shapes and also enhance the sense of spatial depth (see Figure 61).

The Importance of Drawing What You See

It is worthwhile to reiterate that effectively drawing perspective requires that you look closely and draw what you actually see, not what you think you see. If you rely on what you know to be true about shapes of forms you will be tempted to draw them accordingly, and this will not result in a convincing image in perspective. However, if you look closely and constantly compare relationships, that is all you need to do to prepare yourself for successfully rendering perspective. The drawing in Figure 62 shows how convincing the description of perspective can be when you look closely at the subject matter.

Fig. 61 *Value used to accentuate three-dimensional form in room interior*

Fig. 62 *Perspective drawing of jars and boxes*

❖ SKETCHBOOK ASSIGNMENT

Materials: Sketchbook, charcoal

Directions: Do a drawing every day. Date each drawing.

Draw interiors of rooms. Choose large or small areas that require the use of perspective. Use value in these drawings. Try to capture as much light as you can through the use of cast shadows.

♣ DRAWING CRITIQUE

What Are the Objectives?

The objectives for the drawings in this chapter are to create a sense of light, volume, and spatial depth in your drawings through the use of perspective and the depiction of cast shadows.

The method for perspective used in these drawings is sighting perspective. It requires that you look closely at lines, angles, shapes, and

spaces and compare them with each other. The important factor to keep in mind is to draw what you actually see, not what you think you see.

How Do You Determine if the Objectives Have Been Accomplished?
The effects of using sighting perspective should be clear in the drawings. There should be a convincing description of three-dimensional space on the flat surface of the drawing. This depiction of space should be seen from a single point of view. We should be able to easily determine where that point of view would be in relation to eye level. It should seem as if everything was drawn from the same eye-level position.

There should be a sense of light in the drawing. This light should appear to come from an external light source. This light is created in the drawing through the use of cast shadows and the depiction of value on the various planes of form. The articulation of light should support the perspective drawing and reinforce the description of dimension in the forms.

You should be able to perceive space in the drawing, as if you could visually move behind the picture plane.

**Questions to Ask Yourself When Discussing Drawings
for Exercise 15 and Exercise 16**

1. Are you convinced by the description of perspective? Why or why not?
2. How does the use of perspective in this drawing affect the overall sense of spatial depth and of volume in the forms?
3. How does the use of value in cast shadows affect the drawing?
4. Is there a presence of light in this drawing, and if so, what creates this presence?

One always begins by imitating.

Eugène Delacroix

Chapter 11: Copying Drawings

This chapter does not include a journal exercise or information on critiques because the basic drawing exercise is somewhat unique in comparison to our other drawing assignments. In this chapter, your drawing assignment is to copy a drawing done by a significant artist of the past or of contemporary times. There is really no need to analyze the results because what you get out of the process of doing it is really what is there to be scrutinized, and only you can fully know what that might be.

Traditionally, artists have copied other artists' work as a way of improving and understanding their own. Even the most established of artists do this. The copy is not an end in itself, but instead, it is the process of looking at an image in the way you must to copy it that is the goal of this assignment. By carefully emulating another style of drawing you can improve your hand, eye, and mind coordination, and you can learn about other styles and techniques of working. Doing this exercise can have a positive influence on your personal drawing style as well.

Selecting a Drawing to Copy

When choosing the drawing that you will copy, find a style of drawing that attracts you. In other words, try to find imagery that you feel in some way will hold your interest and improve your drawing skills.

Work directly from an original drawing if possible; otherwise work from a reproduction in a book, not a photocopy.

Select the work of a significant artist. This is important because you can only learn from the best examples. You may wonder how to determine who is or is not a significant artist. The best way to solve this problem is to go to a museum or library and explore. Browsing through a museum gives you lots of help in choosing a suitable work to copy. Or, if this is not possible, looking through drawing books on the library shelf serves the same purpose.

Materials Used in the Original Drawing

When copying drawings, use the same medium as the original. For our purposes in this book, it is best to choose original drawings that were done in charcoal because you are familiar with this medium. Working with charcoal when copying drawings reinforces what you have already learned in this book.

If you can determine the paper used in the original drawing, and it is available, then this would be the best choice. However, if this is not possible, choose a good quality drawing paper such as Arches or BFK.

Proportion Ratio of the Picture Plane to the Original

It is best to copy the drawing as large as possible on the paper you choose. Doing so allows you more freedom of movement and ease of control than working on a small scale. In many cases, this means that your drawing will be larger than the original.

You will draw the picture plane on your paper as usual. However, in this case, it is important to measure the picture plane carefully so that you have the same ratio height to width in the original and in your drawing. If you make an error in this measurement and the picture plane in your drawing has a different relationship between the height and width than the original, your job will be difficult, if not impossible.

If you are using a reproduction from a book, measure it directly from the book. Using these measurements, determine the dimensions of the picture plane in your drawing as follows:

1. Determine the measurement for the longest side (height or width) of your drawing by multiplying the longest side of the original by the largest number possible. For example, if the original is 3 inches by 4 inches, then its longest side would be 4 inches. If your paper is 24 inches by 30 inches, then you can see that multiplying the longest side of the original (4 inches) by 7 would give you the correlating dimension in your drawing (28 inches).
2. To determine the measurement for the other dimension in your drawing, multiply the opposite length (3 inches) in the original by the determined number (7).

This would make the dimensions of your drawing 28 inches x 21 inches.

✦　　BASIC DRAWING EXERCISE 17

Subject Matter:　Reproduction of a drawing done by a significant artist

Objectives:　In this exercise, you are copying the original drawing closely. Doing this introduces you to the techniques and styles of the chosen artist, strengthens your ability to see, and broadens your understanding of the elements of drawing.

Directions:　Determine the size of the picture plane in your drawing by measuring and duplicating the ratio of height to width in the original. Draw the edges of the picture plane and mask off the edges.

If the original drawing appears to have a ground or the use of eraser, put down a ground in your drawing.

Using very light marks, begin to draw in the major shapes you see in the original drawing, looking closely at relationships and proportions. Continue working on drawing in the shapes until you are satisfied that the relationships and proportions compare accurately with the original.

Finish the drawing by putting in the details that you see. This would include any shading or use of value. Try to copy the types of marks or strokes that you see in the drawing, using whatever devices you can to do so.

✝ REFINING YOUR SKILLS

Determining Whether to Use a Ground

Once you have determined the size of the picture plane in your drawing, decide whether or not you will use a ground. Using a ground makes it easier to correct the drawing in its initial stages. However, whether you choose to use a ground depends on the style of the original drawing. For example, if you look at Figure 63, a copy of a Rembrandt drawing, it is obvious that a ground would work for this drawing. There are remnants of the ground still remaining and the eraser marks are visible. In comparison, Figure 64, a copy of a Munch drawing, is not as suitable for using a ground. The white of the paper is an important element in the original drawing and using a ground would make it difficult to preserve this quality in the copy.

If you are going to use a ground, begin by applying it to the surface of your paper. Otherwise, begin drawing directly on the paper.

Beginning Step to Establish Proportions

The first step is to do a light contour drawing of the lines and shapes in the original drawing. In this stage you are trying to get down the proportions of the image as accurately as possible. You may have to do this step several times. Don't settle for anything less than accuracy.

Do not use gridding or rulers. The major benefit in doing this drawing will be the increased ability you have to measure with your eyes and to

Fig. 63 *Use of ground in a copy of a Rembrandt drawing*

Fig. 64 *A copy of a Munch drawing not suitable for using a ground*

develop your hand-eye coordination accordingly. For this to take place, you must not rely on mechanical means to measure.

As you work to define accurate proportions and relationships in this drawing, notice that in some ways it is similar to the perspective drawings you did in the last chapter of this book. You are making comparisons between lines, shapes and spaces. In this case, because you are doing a figure drawing, most of the lines are curvilinear. But aside from that, the principles are the same as in the perspective drawings. You can use the edges of the picture planes as reference point for measuring other elements. In Figure 65, measuring the relationship of the head to the

Fig. 65 *Use vertical edges of the picture plane to gauge measurements when copying drawings such as this one by Pierre Joseph Proud'hon.*

torso and then to the legs becomes much easier when you use the vertical edge of the picture plane as a gauge of distance. When you draw a line or shape, you must see it in relation to everything else you have drawn. Using the edges of the picture plane as reference points makes this challenge easier.

In this drawing the negative spaces become key factors. They can be useful guides in determining the accuracy of lines and shapes. Looking at the negative space is often a helpful way to double check for accuracy. In the reproduction of a Peter Hurd drawing (Figure 66), the positive shape

Fig. 66 *Look at negative spaces to check for accuracy in
this copy of a drawing by Peter Hurd.*

of the figure is complex. The student had to capture every nuance in direction of the contour line delineating that shape. Looking at the large negative space surrounding the figure was extremely helpful in this process.

Developing the Drawing Further

Once you are satisfied with the accuracy in the first step of your drawing, you can begin putting in values (if any) and copying the style of the drawing. The surface of your copy should look similar to the surface of the original. Of course, if you are working from a reproduction you are limited in how much you can see of the qualities in the original. Nevertheless you should still be able to see enough to make a good facsimile. In Figure 67 the student has done an excellent job of copying the marks she saw in the reproduction of this drawing. She had to stretch her understanding of how to use the medium of charcoal in order to do this.

Fig. 67 *Test your understanding of the charcoal medium by attempting to duplicate the marks on the surface of the reproduction you are working from in copying a work such as this drawing.*

Here again, keep working until you are satisfied you have done the best you can in copying the drawing. The further you push yourself in this drawing exercise, the more you will learn from doing it.

Conclusion

Now that you have completed the basic drawing exercises in this book, you have a firm foundation in the skills necessary for drawing. In the beginning of this book you learned the importance of looking closely. That is the basis for everything that follows. Knowing how to truly observe your subject matter gives you freedom to respond to what you are seeing and to allow your perceptual skills to do the rest.

Next, you learned to concentrate and to have patience. The importance of these skills cannot be overstated. Being able to focus on your drawing and give attention to every detail is a critical tool in learning to draw. Not only that, but this skill can be applied to many other areas of your life and increase your abilities there also.

After learning to look closely and to concentrate fully, you learned about contour lines, negative spaces, textures, and composition. At the same time you improved your ability to measure proportions and relationships and to establish a strong connection between your mind, eyes, and hands.

Next, you learned how to see and use value. This opened up a wealth of possibilities in your drawings, giving you the freedom to develop surface, light, and form.

Finally, you learned how to see and articulate perspective in drawing. This gives you the last important basic tool in your drawing foundation. Now you can convincingly describe the form of objects and the space in which they are arranged.

What lies ahead? You can use these basic skills, work independently, and continue to learn and improve your drawing. This book will serve as a companion to your drawing experience—read and reread it when you feel the need. You can be confident that everything you have learned thus far is yours; you won't forget it.

If you take more drawing classes, there are other elements in drawing to explore and skills to learn. What you have learned in this book is only a beginning in that regard. But it is a sound beginning and should give you the confidence as well as the abilities you will need to face the challenges that you meet ahead.

Glossary

additive process Process in which materials are added to the drawing surface as a way of developing an image. (Example: drawing with charcoal) (page 65)

closed composition Composition in which all of the forms are contained within the edges of the picture plane. (page 104)

composition The arrangement of shapes within the picture plane; the relationship of all lines, shapes, and other elements of the drawing to the four edges of the picture plane and to each other. (pages 21, 22, and 94)

contour The line that defines the shape of a form. (page 11)

eye level The height at which your eyes are located in relation to the ground plane. (page 106)

figure/ground relationship The relationship between positive shape and negative space. (page 33)

fixed point of view The same and exact position of the viewer's eyes in relation to the subject matter. (page 100)

form The shape, structure, and volume of actual objects in our environment, or the depiction of three-dimensional objects in a work of art. (page 26)

format The overall shapes and sizes of the drawing surface. (page 101)

ground The prepared surface upon which you draw. (page 65)

linear perspective A logical system of rules for creating the illusion of three-dimensional space on a two-dimensional surface. (page 99)

line The path of a moving point or a mark made by a tool or instrument as it is drawn across a surface. (page 13)

local values Values intrinsic to a form and separate from the lights and darks created by light falling on forms. (page 71)

negative space The area surrounding the shape of the object that is the subject of a drawing. (page 33)

perspective The representation of things on a flat surface as they are arranged in space and as they are seen from a single point of view. (page 99)

picture plane In drawing, the two-dimensional surface on which the artist works. (page 12)

positive shape The shape of the object that is the subject of a drawing. (page 33)

proportion The relative size of part to part or part to whole within a composition or object. (page 103)

scale The relationship of size between one form and another. (page 13)

sighting perspective A method for drawing perspective that relies on what the artist observes rather than on a set of rules. (page 99)

surface The physical exterior plane of a drawing. (page 77)

structure The arrangement of parts in a form. (page 41)

subtractive process Process in which materials are removed or taken away in order to develop an image. (example: drawing with eraser) (page 65)

texture The surface character of a form. (page 41)

three-dimensional form Form that conveys a sense of height, weight, and depth. (page 26)

value The many observable tones from light to dark, from white through gray to black. (page 11)

viewfinder A framed opening through which you can see a selected part of the visual information in front of you. (page 100)

volume The three-dimensional quality inherent in every form. (page 87)

Index